THE CAMERA PHONE BOOK

SECRETS TO MAKING BETTER PICTURES

By Aimee Baldridge
Photography by Robert Clark

NATIONAL GEOGRAPHIC

WASHINGTON, D.C.

Around the world, millions of people carry camera phones with them. In just a few years, the camera phone has quietly become the most widely used kind of camera in the history of photography. By combining photography with communications, it also has the potential to become the most influential. Today, camera phones are both more and less like other digital cameras than you might realize. Advanced models provide many of the settings and tools you can find in digital pocket cameras, including video features. But they also offer innovative functions that let you use images to communicate with others, link up with other devices, and bridge the gap between the virtual and physical worlds. The challenge of integrating a camera into an extremely compact, mobile, multifunction device is driving new developments in optics and imaging technology as well. And

as Robert Clark's photographs in this book show, a camera phone in capable hands can produce compelling images. The goal of this book is to put mobile-imaging options in your hands when you're selecting a camera phone, taking pictures and exploring new ways to share your view. The National Geographic Society has always been at the forefront of innovation in photography, and the growing world of camera phones is our newest frontier. We hope you will be inspired by the tools, techniques, resources and images presented here.

AIMEE BALDRIDGE is a writer and photographer based in New York. She covers photography and imaging technology for a variety of magazines and online publications, and was previously a senior editor covering digital imaging at CNET Networks Reviews. She holds a B.A. in English Language and Literature from the University of Chicago. You can see more of her photography at www.aimeebaldridge.com.

Creating this book required the skill and hard work of many people. I extend my thanks to all of them, and to Russell Hart for recommending me. Representatives of companies mentioned in this book were also generous in sharing information and letting me give their products a spin. Special thanks to Camilla Gragg, Kristen Kelly and Drew Crowell. I would like to thank my family and my excellent friends for their love and enthusiasm. Special thanks to my mother for her indispensable support and to Shams, Ted, Anne, Sara, Bill, Evie, James and Chris — and definitely to Bryan, who made me my own custom infrared camera-phone light. I'd also like to remember Anil Ramayya for the friendship and encouragement he gave me in all of my endeavors.

CONTENTS

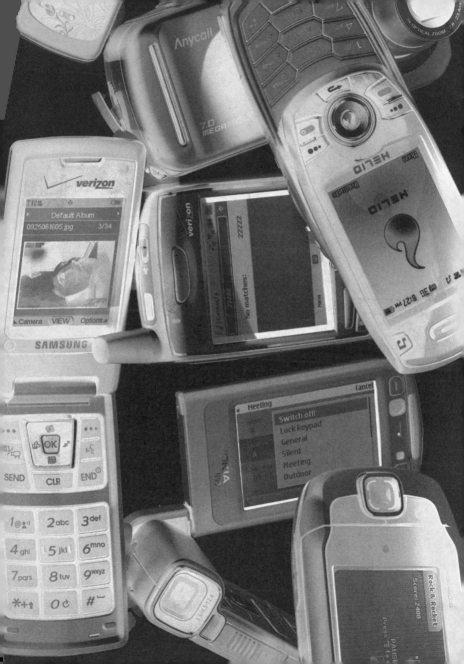

Back when the cameras in mobile phones were little more than cheap, low-quality toys, their imaging capabilities probably didn't wow many buyers. But now that matters have improved, the time you take to learn about camera-phone options and compare different models will be well spent. There are several elements to consider: the mobile-service provider and service plan you choose, the camera phone's design, the quality and characteristics of its imaging components, and the software it can support. All of these factors affect how well your camera phone will function as a mobile-imaging device — in other words, how much you're going to enjoy taking pictures and doing other cool imaging-related stuff you might not have known was possible with a camera phone.

DESIGN

Fusing a camera with a phone is no mean feat; but doing so has resulted in a broad variety of camera-phone sizes and physical configurations. To find the design that works best for you, look over the types shown here and then go to a store and test drive a few to see what feels right.

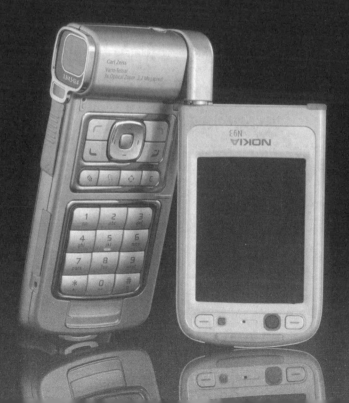

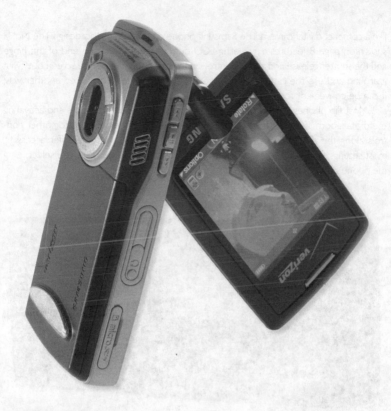

FLIP PHONES

A flip or clamshell style is one of the most common camera-phone designs. In simple flip phones, the lens is on the front cover and the LCD/viewfinder on the opposite side. Many flip phones have a lens at the bottom of the front cover; but some have one near the hinge at the top of the phone that can rotate. That means more flexibility in shooting from different angles and also allows you to take pictures with the cover closed, using the external LCD as a viewfinder. More elaborate flip designs place the lens on the back cover and allow the front cover with the LCD to swivel as on the Samsung phone shown above. With that type of design, you can rotate the LCD and fold it down against the body of the phone with the screen on one side and the lens on the other,

like a compact digital camera. The Samsung phone on page 9 has this design. The Nokia shown on page 8 features a swiveling LCD but has the lens on one end of the hinge and the shutter release and zoom control on the other. You can flip the screen out, twist it around and use the camera phone like a small camcorder. Configured another way, it can be convenient for viewing pictures.

Most flip phones have buttons along the sides for snapping pictures and activating the digital zoom. If there's enough room, there are sometimes buttons for other controls along the side or surrounding the LCD. But all camera-phones offer access to most settings through the menu system and icons on the screen that you select using the phone's main keypad.

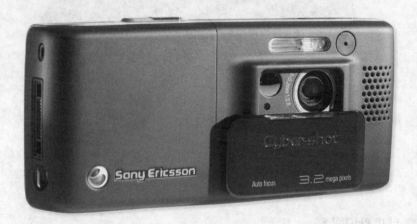

BAR PHONES

Bar phones are composed of one solid piece with no moving segments. That makes them well suited to imitating a typical compact digital-camera design, with the LCD and phone keypad on one side and the lens on the other. With the lens on the back of the phone, there's more room for a built-in cover and for space between the lens and a built-in flash.

The Sony Ericsson bar phone shown here has a design resembling some Sony Cybershot ultracompact digital cameras: The camera turns on when the lens cover is opened — faster and more convenient than activating the camera through the phone's menu system.

MEMORY CARDS & INTERNAL MEMORY

All camera phones have at least a small internal memory for storing photo and video files. Internal-memory capacities are typically between 8MB and 160MB; but the number of images you can store will depend on the camera resolution and video format used. Some phones offer more flexibility, with a slot for a flash-memory card.

These removable memory cards are used in digital cameras, PDAs and sometimes MP3 players to store files. But while those devices use full-size cards such as CompactFlash, SD, MMC and Memory Stick, camera phones accept only much tinier mobile-memory cards. These cards resemble the larger versions and often have the same names with "mini" or "micro" tacked on; but they are much smaller. A few camera phones use full-size cards. Those are usually smartphones similar to PDAs in their design and functions.

Insert your mobile-memory card into the appropriate slot on the side of the camera phone or sometimes in the battery compartment. (Do not confuse this card with your phone's SIM card, which actually stores your phone's numbers and call information.) Select the memory-card option in either the phone's settings or camera menu so images will be saved to the card.

Bar phones also tend to have more room for buttons and other physical controls than some other camera-phone types. It may look less sleek, but you have dedicated physical controls for important camera functions. Shutter-release and digital-zoom buttons are generally on the sides of the phone.

Some larger bar phones available soon look very much like a compact digital camera, with numerous buttons on the body to control camera functions and even a retractable zoom lens.

Bar phones with advanced camera features tend to enable a horizontal orientation, with shutter-release and zoom buttons where you would expect them on a camera, and the lens situated so you don't block it when holding the phone as you would a camera. Bar phones that don't emphasize camera features generally place the lens near the top of the back of the device, making it more natural to hold the phone in the same vertical orientation you would use when making a call.

SLIDE PHONES

Slide phones are composed of two segments placed one on top of the other. To open them, slide the top segment back to expose the phone's main keypad. This type of design combines some of the virtues of flip and bar phones. Closed, they're more compact for carrying; but even very compact slide designs have enough space on the body to accommodate a good number of buttons and sometimes a built-in lens cover. Slide phones also have space for physical controls below and sometimes above the LCD on the front cover. This is usually where you'll find controls that allow access to some functions when the phone is closed. You also might find camera options in models with lenses that are exposed when the phone is closed.

Some slide phones — like Pantech's Helio model shown facing — have lenses on the back, allowing room for a built-in lens cover and a built-in flash that isn't right next to the lens. This design also lets you hold and operate the closed phone horizontally, much as you would a compact digital camera. For example, on the Helio Hero, the shutter release is right where you'd expect it to be on a camera; and you can turn the camera on by reaching around the front with your finger and flipping the lens cover open. Controls around the LCD let you change camera settings.

Other slide phones, such as the LG model shown on page 51, have the lens on the back of the front segment of the phone. When the phone is closed, the lens is covered and protected by the back of the phone. When you slide the phone open, the lens is exposed. This approach tends to favor vertical shooting. On the LG phone, the shutter-release and zoom buttons are on the upper sides of the top segment, making it natural to hold and operate the phone vertically when taking pictures.

QWERTY PHONES

Some camera phones incorporate a full QWERTY keyboard for thumb typing. Their designs tend to fall at the extremes of the coolness spectrum. Some are staid devices that look like PDAs with antennas; others are stylish gadgets meant to appeal to people who wouldn't dream of sullying the keyboard by typing business correspondence. There are many variations in the design of this type of camera phone, but having a QWERTY keyboard gives them all one thing in common: They're fairly large. This may make them a little less comfortable to carry around in a pocket; but it also means they usually have large LCDs, which you'll

TYPES OF MEMORY CARDS

There are several types of mobile-memory card; and they're not interchangeable. If your camera phone has a memory-card slot, only the specified type will fit.

The most common mobile-memory cards are:

Memory Stick Micro

microSD (a.k.a. Transflash)

miniSD

RS-MMC and MMCMobile (MMC Mobile is a higher-speed version of RS-MMC that saves images faster than an RS-MMC)

Some types are available with capacities as high as 4GB. But some camera phones can't use cards with very high capacities.

When you purchase a mobile-memory card, it should come with an adapter that allows you to put it in a full-size memory-card slot. This lets you insert it into a card reader or another device with memory-card slots not made specifically for mobile-memory cards. However, memory-card readers with dedicated mobile-memory card slots are available. Try:

ATP
www.atpinc.com
Lexar
www.lexar.com
Kingston Technology
www.kingston.com
Sandisk
www.sandisk.com

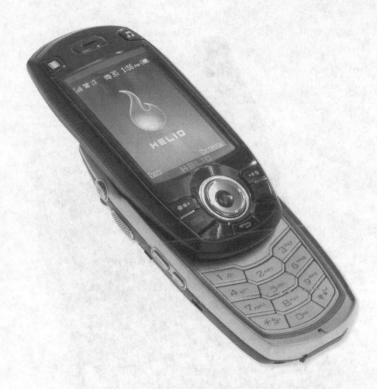

appreciate when using yours as a viewfinder or a playback screen for images you've shot. QWERTY camera phones usually have the keyboard and LCD on the front and the lens on the back. There are phones with full keyboards that have slide or clamshell flip designs; but they still generally place the lens on the back of the phone.

Palm's Treo phone (p. 14) falls into the staid, business-oriented category. It has a touch screen and comes with a stylus. However, despite the many buttons and touch-screen controls accessible on this model, there are relatively few camera controls. The cameras in phones of this type are expected to be used more for practical purposes — such as photographing documents or work sites — than for leisure, so there isn't a great deal of attention given to creative controls or quick-access camera functions for sponta-neous snapshots. On the other hand, business-oriented QWERTY camera phones have

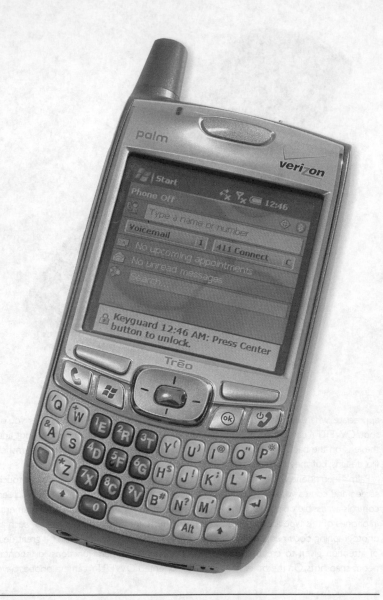

LIGHTS FOR
STILLS AND VIDEOS

Many camera phones incorporate built-in lights to illuminate photos and videos in low light. There are two main types: LED (light-emitting diode) and Xenon, which uses a tube containing Xenon gas.

LEDs are the most common type of built-in light. They're quite small and are generally less powerful than the kind of flash in a compact digital camera. They have a limited range, which means subjects must be close to the camera phone to be illuminated by an LED, and background elements in a dark environment probably won't be. An LED may also fail to cover the full breadth of the image, so pictures are dimmer around the edges. But LEDs use relatively little power and won't tax your battery too much. Another important advantage: They can be used for both photos and videos. For photos, they can be set to emit a quick burst of light, like any camera flash. For videos, they can also be used as continuous light sources for the length of your film. Xenon flashes are more powerful, have a longer range and can illuminate an image more evenly. But they drain the battery more quickly and can't stay on for videos.

Many built-in camera-phone lights are placed very close to the lens, making it more likely people in your pictures will have red eye. Look for a flash that keeps a little distance from the lens.

powerful software platforms, making it possible to run some of the most interesting and advanced mobile-imaging applications.

The Sidekick (a.k.a. Hiptop) phone is one of the QWERTY models with more panache. When it's closed, the LCD sits in a shallow well over the keyboard, integrating smoothly with the body of the phone. You can take photos and videos with it when it's configured this way, holding it much as you would a digital camera with a horizontal orientation. The shutter-release button falls under your right index finger, and there's a zoom toggle on the bottom under your left thumb. Buttons next to the LCD give you access to camera settings. When you give the front of the LCD panel a little nudge, it spins around and flips up, exposing the keyboard. You can also take pictures when the LCD is up, although this configuration lends itself more to reviewing images than to taking them. QWERTY clamshell-design phones function similarly, letting you use a secondary, external LCD on the front cover as a viewfinder when the phone is closed.

OUTLIERS

Camera-phone designers work with many constraints. The device has to be compact and durable yet still provide reasonably easy access to a plethora of functions. But there is a lot of opportunity for innovation in camera phone designs as well, and new technologies are constantly expanding the options. Here are two examples of innovative camera phones that don't quite fit into the main design categories described in this chapter.

Nokia makes a one-segment phone that doesn't look much like any of the other bar phones around. When the power is off, the front of the device has a mirror surface; when you turn it on, the LCD appears there. Next to the LCD, a control dial surrounded by

four buttons (two per outer curve) replaces the usual keypad and works surprisingly well for navigating LCD menus and operating various functions, including the camera. The lens and an LED light are on the leather-covered front of the phone.

The tiny NEC camera phone shown above also has a bar phone's single-segment design, but it's only as tall and wide as a credit card and about half-an-inch thick. What makes this extremely compact design possible is the device's touchscreen LCD. You access all the phone functions and other controls through it, with either your finger or the stylus that slips into a built-in socket when you're not using it. Among the very few buttons on the sides of the phone is the shutter release, which falls under your right index finger when you hold the phone horizontally, just like on a compact camera. The lens is on the back. When you're taking pictures, icons appear along the edges of the LCD, providing a more efficient system for changing basic settings than many button-controlled menu systems. Simply tap the icons to cycle through your options.

CAMERA MENUS AND MOBILE WEB BROWSERS

Since camera phones have little room for buttons and other physical controls, they provide access to many camera settings and image-editing functions through a menu system displayed on the LCD. You navigate it using buttons on the phone, just as you would a menu system on a digital camera. When trying new models, test the camera menu system.

A well-designed camera phone uses efficient menus requiring few buttons to change important settings. Essential features such as exposure compensation should be accessible with just one press. Image-editing menu design is less important, since you'll likely have more time to fix up your shots. But those menus should be intuitive and not require a frustrating number of buttons to view images and make changes.

If your camera phone is capable of connecting to the Internet, it probably came with a mobile Web browser installed. Some preinstalled browsers are very good, but if you don't have one or want a better interface for surfing to your moblog and online photo albums, you can try one of these:

Minimo
www.mozilla.org

NetFront for S60
www.access-netfront.com

Opera Mobile and Opera Mini
www.opera.com

A well-made camera phone is like a first-rate hotel room: It gives you all the best views. The quality of your images will depend on the quality of the camera's view through the lens and the view it gives you on the LCD.

RESOLUTION AND SENSORS

When shopping for a camera phone, you may see a lot of megapixel numbers thrown around. If judging by the ads, you might guess that megapixels were some sort of rating system: The higher the number, the better the camera phone. This is not the case. Having more megapixels isn't a bad thing; the situation is just more complicated than a simple correspondence between megapixels and image quality. To understand it and cut through the advertising, you need to know a little about camera-phone image sensors.

Sensor resolution How sensors work is a topic complex enough to fill a large book of its own. In the most basic terms, a camera-phone sensor converts light into electricity and then converts that electricity into the digital data that will be stored in an image file.

A camera-phone sensor is a small CMOS (complementary metal-oxide semiconductor) chip whose surface is covered with rows of photosites. The photosites are like little wells that collect the light coming in through the lens and put it on the path to becoming digital data. The light collected by each of them becomes one picture element, or pixel; and all the pixels together make up the image. The total number of pixels defines the sensor's resolution, which is why resolution is described in terms of pixel counts.

So if a camera phone's resolution is 1280x1024, there are 1280 rows of pixels on the sensor horizontally and 1024 rows vertically, for a total of 1,310,720 pixels. That number is then shortened to 1.3 megapixels, "mega" meaning million. For convenience, resolutions above 1 million pixels are counted in megapixels, while smaller resolutions are often described by acronyms that correspond to specific resolutions. They are:

VGA: 640x480 QVGA: 320x240 CIF: 352x288 QCIF: 176x144

As a rule of thumb, you'll need at least a megapixel of sensor resolution and preferably two to produce a decent 4x6 print.

Image resolution The term "image resolution" describes how much detail is shown in an image. Camera reviewers perform standard tests to determine resolution, including photographing a chart with a series of lines increasingly fine and close together. The finer the lines that appear clearly in the test photograph, the higher the image resolution. Resolution cuts off when lines that are clear on the chart start to blur together in the photograph. Image resolution is often described in terms of number of lines per inch, or the maximum number of lines per inch that can be produced clearly.

How the two are related All other things being equal, if you increase a camera phone's sensor resolution, you will increase its image resolution. But all other things are not equal. If you pair a high-resolution sensor with a low-quality lens, you'll make low-quality pictures. The system that processes the image data produced by the sensor can also cause image-quality problems if it's not up to snuff.

Other sensor characteristics can affect image quality and resolution. A bigger sensor with larger, more widely spaced photosites can generally capture images more easily in low light and is less prone to producing visual flaws than a smaller sensor with tiny photosites. Sensors also affect image quality by producing visual noise. Noise increases the more you amplify the electrical signal created when light is converted to electricity, either to compensate for low light or because you've bumped up the camera phone's ISO setting.

The moral of this story is that a high sensor resolution is necessary but not sufficient to produce an image with high resolution. So buy as many megapixels as you can afford, read product reviews, pay attention to the lens, and be aware that a high sensor resolution is not a guarantee of good image quality.

LENS TECHNOLOGY TO LOOK FOR

Innovative lens technologies hold the promise of improving the images produced by camera phones, increasing their ability to capture images in low light and enhancing their autofocus and image-stabilization functions.

Companies such as Varioptic and Philips have developed lenses that incorporate fluid elements. This allows them to be very small, use less power than conventional lenses and autofocus quickly. The fluid element combines two types of liquid that don't mix. When electricity is applied, the surface where the two fluids meet—the meniscus—changes shape. That alters the focus of the lens. The ability of fluid lenses to change focus very quickly could make great improvements to autofocus during video capture, as well as decreasing shutter lag for snapshots.

Other optical technology developers, including Dblur and DxO, have created systems that combine lenses with software processing to increase image resolution, sharpness and depth of field. These systems employ deblurring, or deconvolution, technology. Their lenses capture blurry images and improve low-light capture. By specifying the way the lens blurs the image, the companies can then create software algorithms that correct the blur precisely.

LENSES

Compare the following features when considering camera-phone

lenses: the general quality of the optics, whether they have an optical zoom, and whether they offer autofocus. It's also good to know a bit about how lens apertures affect images, although camera phones don't offer much selection in that area.

Optical quality It's difficult to determine the quality of the optics just by looking at the lens, and few camera-phone makers provide lens specifications. Common sense usually can guide you: If the lens is tiny and unmarked on an inexpensive phone, it's probably not very good. If it's larger and the manufacturer has put f-stop and focal-length numbers on it, it's probably a better one. Glass lenses are generally better than plastic ones, although it can be hard to tell what a camera-phone lens is made of just by looking.

The brand of an optics maker — like Carl Zeiss — can indicate a quality lens. It may not be in the same league as the maker's lenses for high-end cameras; but its design benefits from the company's expertise, as well as from better production and quality control than generic lenses.

Optical zooms and focal lengths An optical zoom adds to the cost of a camera phone, but it's an excellent option to have. Optical zoom allows you to physically adjust the lens to a range of focal lengths. Simply put, the focal length is the distance in millimeters between lens and sensor. When you zoom in, you move the lens away from the sensor, increasing the focal length. This magnifies your image and narrows the slice of scene — or angle of view — the lens can see. When you use a shorter focal length — or zoom out — the angle of view is wider.

Most camera-phone optical zooms give you roughly 2.8x magnification, meaning the longest focal length available is 2.8 times the shortest one. While much smaller than the zooms offered by some dedicated digital cameras, this does offer some flexibility in composing images. It lets you choose between using higher magnification to capture a distant subject or take a close-up image, and using a wider angle of view to capture an expansive scene or a group of people in a tight space.

Almost all camera phones offer digital zoom; but it's not the same as optical zoom.

Digital zoom doesn't change the focal length of the lens; instead, it crops and process-es the image with software. The more you enlarge an image with a digital zoom, the more you degrade its quality.

Camera phones that don't offer optical zooms have fixed-focal-length lenses. The lens has just one available focal length and, therefore, just one level of optical magnifi-cation and one angle of view. It's usually a moderately wide view, like what you would see through a 35mm film camera using a lens with a focal length between 30mm and 40mm. Camera phones with optical zooms typically have the same moderately wide angle when zoomed out, and can zoom in to reach the equivalent of a 35mm camera lens between 90mm and 100mm (or moderately telephoto).

Autofocus and fixed focus Most camera phones also have fixed-focus or focus-free lenses, meaning they have no autofocus and can't be focused manually. (Manual focus is still a rare feature to find on a camera phone.) A fixed-focus lens is set to keep as much scene as possible in focus. Some fixed-focus lenses have macro- and infinity-focus modes, accessible through the camera-setting menus. A macro mode adjusts the lens so nearby objects are in sharp focus (just how nearby depends on the specifications of each lens). Infinity modes do the opposite, focusing the lens at infinity so distant objects look sharp. Landscape modes often set the focus at infinity, too.

Autofocus is a nice option to have, since it gives you more control over an image. To use autofocus on a camera phone, press the shutter-release button halfway, and the camera locks focus on the object in the center of the image. If you want that object to be the sharpest element in the picture but don't want it in the center of the frame, just hold the button down and recompose your shot before pressing the button all the way.

Apertures and f-stops There isn't much variety among lens apertures in current camera phones, but it's useful to understand what apertures do. The knowledge will come in handy when more options actually are available.

The aperture is the opening through which light comes into the camera, and its diameter is described in terms of f-stop numbers. The higher the f-stop, the smaller the aperture. The apertures in sophisticated camera lenses have adjustable diameters that typically range from f/2.8 to f/22 but can go even higher or lower. Camera phones don't offer a large selection of aperture settings, or f-stops. Most have just one, some have two, and very few offer more. Camera-phone apertures typically fall between f/2.8 and f/4.0, with f/5.6 used occasionally. In some camera phones with more than one aper-ture setting, the device automatically sets aperture according to the scene mode you select but won't allow you to make manual aperture selections.

ASSIST LIGHTS

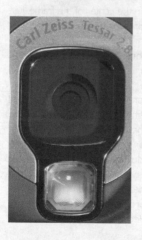

Aperture controls how much light comes through the lens and is one of three elements that determine the exposure of any image you make with either a camera phone or a digital camera. The other two elements are shutter speed, which controls how long the sensor is exposed to light, and ISO setting, which determines how high the gain on the sensor is.

Different combinations of aperture, shutter speed and ISO setting can result in images with the same exposure but with different looks. With a slower shutter speed, a moving subject will be blurred; and with a higher ISO setting, there will be more visual noise in the image. A very wide aperture allows more light into the camera, making a good exposure possible using a fast shutter speed to capture a non-blurred moving subject, or while using a lower ISO setting to reduce noise in the image. In other words, the wider the aperture on your camera phone, the more it will be able to capture sharp, clean images in low light and when subjects are moving fast.

The aperture also affects the depth of field of an image— or the distance in which objects are reasonably sharp— in front of and behind the most sharply focused point in the image. The wider the aperture, the shallower the depth of field. Typical camera-phone aperture settings produce a moderate depth of field. Minimizing the background by opening the aperture is still hard to achieve with today's camera phone.

The other lens You may have noticed that some camera phones have more than one lens. The second lens is for video calls. It's near the main LCD so you can see yourself on the screen and control the image seen by the person you're calling. This setup also gives you access to controls and LCD menus while you're making the video call. To make a video call, you need a connection to a high-speed data network and a data-service plan that includes video calling.

MAKING A PURCHASE

Buying a camera phone from your mobile service provider is often an appealing option, since carriers subsidize the cost of the phones they offer. You end up paying a lot less for a phone when you buy it with a service plan than if you purchased it from a retailer. However, you might want to consider how much you'll use your camera phone and whether it might be worthwhile to pay more for a model that's better at taking pictures than whatever your service provider has on special. If you usually leave your dedicated camera at home and end up taking most pictures with your camera phone, then consider the price you'd be willing to pay for a decent camera instead of looking at your camera phone as an accessory to your call plan.

CAMERA PHONE SOURCES

At least for the moment, you'll be limited to the selection that your service provider offers if you're dealing with a CDMA system. That's not necessarily a bad thing, as long as your service provider has a good selection. If you choose a GSM service provider, you also have the option of buying an unlocked model directly from a phone manufacturer or a retailer. However, you may need to do a little extra work when you purchase a data-service plan if you don't buy the device from the company providing the service. Make sure the necessary support is available from the phone manufacturer or retailer before you make a purchase.

To activate your data-service plan, you'll need to enter information in your phone's setup menus. If you have purchased a phone from your service provider, the company will help you activate its data service on your phone. If you've bought a phone from another source and your service provider won't help you, look for data-service-setup support on the phone manufacturer's Web site. The way it usually works is that you enter information about your phone and service plan on the Web site, then receive setup instructions directly on your phone.

Camera-phone manufacturers Nokia (www.nokia. com), Sony Ericsson (www.sonyericsson.com) and Samsung (www.samsung.com) have been at the forefront of camera phone development, creating some of the most advanced models and supporting the progress of mobile-imaging software and services. Motorola (www.motorola.com), LG Electronics (www.lge.com) and Kyocera (www.kyocera-wireless.com) are also notable for their strong camera-phone designs. While there are too many camera-phone makers in the world to list here, this is a selection of companies

MANUFACTURERS

AMOI
http://www.amoi.com

BenQ-Siemens
www.benq-siemens.com

HTC
www.htc.com

iMate
www.imate.com

Innostream
www.innostream.com

NEC
www.nec.com

Neonode
www.neonode.com

Panasonic
www.panasonic.com

Pantech
www.pantech.com

Sagem
www.sagem.com

Sanyo
www.sanyo.com

Sierra Wireless
www.sierrawireless.com

Utstarcom
www.utstarcom.com

RETAILERS

Telestial
www.telestial.com

USTronics
http://store.ustronics.us

Wireless Imports
http://wirelessimports.com

whose products are worth a look when you're shopping off the beaten path.

Unlocked phone retailers You can find unlocked GSM camera phones from many online sources, including large sites such as Amazon.com and eBay. At left a few specialty retailers that also sell prepaid SIM cards you can use in various countries around the world.

STANDARDS AND SERVICE PROVIDERS

Everyone compares quality, coverage and service-plan fees when choosing a mobile-phone service provider. When you have a camera phone, you should also consider the data-communications services available. The data-service plan you choose will determine whether and how fast you can send images from your camera phone, view photos in Web albums and receive images from other sources.

Service providers are constantly updating their network infrastructures and service plans, so check out a variety of current offerings before choosing one. The major U.S. national and regional service providers all offer an array of data-service plans. Smaller carriers such as Helio, Virgin Mobile, Amp'd Mobile and Dobson also offer data services, sometimes on a prepaid or pay-as-you-go basis. Before signing up for a plan, know the charges for sending an image or surfing the Web.

To send images from your camera phone, you'll need a plan that includes multimedia messaging service (MMS), sometimes called picture messaging or mail. For more advanced features, such as the ability to view your Web albums on your phone, you'll need mobile Web access. The type of data network available to you will depend on the basic mobile-communication standard

PLATFORMS

Software is probably not the first thing that springs to mind when choosing a camera phone, but it's an important consideration. Any camera phone will come with basic software installed, including the camera interface itself and some image-editing and effects tools. But a camera phone that allows you to install additional software will let you add functions that go well beyond the ability to take a quick snapshot.

Many of the mobile software tools described in Chapter 3 are compatible only with camera phones that provide the right software platform to run them. The same is true for imaging-related mobile services, since many of them require you to install a software program on your phone in order to work. In fact, you might first choose the software and services you want, then select a camera phone that will support them.

Smartphones provide the most flexibility. They incorporate powerful processors and run operating systems that support software created by third-party developers. Among these operating systems are Symbian, Microsoft Windows Mobile and Linux. If you don't opt for a smartphone, look for a model that offers a Java or BREW platform. These platforms support third-party mobile-imaging software and services you can download to your phone from your service provider or a third-party software source.

your carrier uses and whether your carrier has made corresponding high-speed data-transfer technologies available in your area.

GSM, CDMA and other letters The two most widely used mobile communications standards are GSM and CDMA. They are separate systems used by different service providers and supported by different phones. Among the major U.S. national carriers, Cingular and T-Mobile use a GSM network, while Verizon and Sprint use CDMA. GSM and CDMA networks each work with separate data-communications technologies. When you choose between GSM and CDMA, you're also choosing what data networks will be available to you. Carriers that use a GSM network may transfer data via GPRS, EDGE, UMTS (a.k.a. W-CDMA) or HSDPA. CDMA networks use 1x-RTT and EV-DO for fast data transfers.

Although GSM and CDMA are the most common standards, they're not the only ones. In the U.S., Sprint Nextel and some smaller carriers use the iDEN standard with its corresponding WiDEN high-speed data standard. WiDEN is roughly comparable to the lower-speed GSM and CDMA data networks. The phones that use iDEN are Motorola models that offer push-to-talk two-way-radio features. Motorola also makes dual-mode iDEN phones that incorporate GSM SIM cards for roaming in areas where iDEN networks are not available. Some smaller carriers use the older TDMA standard, although they are generally switching to GSM or CDMA networks. Although GSM is the predominant standard abroad, a few countries, mainly in Asia, use the PHS, PDC, TD-SCDMA standards.

Smart cards There's another important difference between GSM and CDMA. Phones that support the GSM standard use removable smart cards called Subscriber Identity Module (SIM) cards. When you open an account with a GSM service provider, the provider gives you a SIM card. It usually comes installed in a slot in the battery compartment of the phone you select when you first purchase a service plan. The SIM card stores your account information, along with any phone numbers and other call-related data you later enter.

The advantage of this system is that once you have a SIM card, you can put it in any GSM phone. This means you have a removeable electronic database of phone numbers. Conversely, you can put any SIM card in your GSM phone. That means you're not obliged to buy your next phone from your service provider in order to retain your account. If you travel to another country where there is GSM service— many countries use this standard— you can buy a prepaid SIM card from a local carrier, put it in your GSM phone, and pay local rates instead of exorbitant roaming

charges. There's just one catch: A phone must be unlocked in order to be compatible with all SIM cards.

Unlocking a GSM phone Service providers often "lock" their GSM phones so they can't be used with another company's SIM cards. You may have to unlock your phone if you want to use a different SIM card. Unlocking some phones is just a matter of entering a code. Other phones require firmware changes. You can find businesses online that sell unlocking codes and can change the firmware on a phone you send them. A code shouldn't cost more than five or ten dollars. Check refund policies in case a code doesn't work, and do a little online research to make sure you're dealing with a legitimate business before you ship them your phone.

CDMA pros and cons The CDMA phones sold in the U.S. don't use smart cards, although some Asian models have Removable User Identity Module (R-UIM) cards that serve the same purpose as SIM cards. Until R-UIMs travel west, your account and call information will be programmed into the phone itself when you buy a service plan with a provider that uses CDMA. That means your choice of camera phones will be limited to what the provider offers. However, CDMA call quality is generally considered to be good; and CDMA service providers often make a variety of camera phones available.

International camera phones If you travel outside the U.S., choose a camera phone that can accompany you. Mobile phones transmit voice and data via radio waves. GSM models use the 1.9GHz and 850MHz frequency bands in the U.S. and the 900MHz and 1.8GHz bands in many other countries. Quad-band GSM phones transmit on all of these frequencies, and tri-band phones on three of them. CDMA phones use a wider spread of frequencies. If you're using one, check with your service provider to find out where roaming service is available before you leave the country. If you discover the phone is unuseable when you get to your destination, you may have to buy or rent a new phone where you are.

WiFi and WiMAX Some camera phones come with built-in ability to connect to a wireless local area network (WLAN) via the 802.11 WiFi standards. If your camera phone has this feature, you can connect to available WLANs and send images and other data over the Internet. WiMAX is a mobile wireless broadband technology that promises fast data transmission to and from compatible phones via the 802.16 standards. We should expect to see greater network support and phone compatibility for both WiFi and WiMAX in the future.

The Camera Phone Rosetta Stone

is a guide to the camera settings, tools, and controls available on mobile phones. No camera phone has all of them, and few of them are found on every camera phone. If you're choosing a camera phone, the Rosetta Stone will give you an overview of features available so that you know what your options are. You can read this Rosetta Stone the way its namesake was deciphered, by using the

Feature	Typical icon or abbreviation	What it does
IMAGE QUALITY		
Resolution (aka Size)	⊡	Lets you select how many pixels make up each photograph or frame of video.
Compression (aka Quality)	◇	Lets you select the level of compression used when saving the image file.
Video frame rate	FPS	Determines how many image frames per second are captured.
EXPOSURE AND COMPOSITION		
Exposure Compensation (aka Brightness or Exposure Value)	+/-	Increases or decreases exposure, making the image brighter or darker.
Average Metering	☐	Sets exposure based on the average brightness of the entire image.

things you already know about each feature to find out the things you don't. Skim the "especially good for" column to find the settings that will be most useful for the types of shots covered in each of the techniques explained in Chapter 2.

If you have a smartphone or a model with a Java or BREW platform, you'll be able to expand its functions by installing third-party software. Look for programs that are compatible with your phone on your service provider's Web site and software download sites, as well as in Chapter 3 of this book.

Especially good for	AVAILABILITY	Tips
	UBIQUITOUS	The higher the photo resolution, the larger you can print.
	UBIQUITOUS	The lower the compression, the higher the image quality.
	UBIQUITOUS	Frame rate options are usually combined with resolution or compression options into one set of video quality selections.
All Types of Pictures	UBIQUITOUS	This is one of the most important features. Make sure it's easy to find and use on the phone you buy
Landscapes, Buildings and Interiors, Documents	UNCOMMON	Best for scenes without extremes of brightness. Some camera phones without selectable metering use this automatically.

Feature	Typical icon or abbreviation	What it does
Center-Weighted Metering	⊡	Sets exposure based on the average brightness of the entire image, but gives more weight to the center of the frame.
Spot Metering	⊡	Sets exposure based on the brightness of a small area at the center of the image, disregarding how the rest of the frame is exposed.
ISO setting	ISO	Increases or decreases amplification of the image captured by the sensor, making it brighter or darker.
Aperture-priority mode	A	Lets you select an f-stop and automatically sets the shutter speed and ISO for proper exposure.
Shutter-priority mode	S	Lets you select the shutter speed and automatically sets the f-stop and ISO for proper exposure.
Manual exposure mode	M	Lets you select the shutter speed and f-stop.
Flicker Cancellation	none	Syncs shutter speed with fluorescent light cycle to reduce flicker in video and exposure flaws in photos.
Histogram	none	Shows a graphical display illustrating the range of brightness values in the image.
Zoom	Q	Adjusts internal parts of the lens to change its focal length.
Guidelines	none	Displays a grid on the LCD preview for aligning the horizon and applying the Rule of Thirds.

FOCUS

Autofocus	AF	Moves internal parts of the lens (and sometimes applies image-processing algorithms) to bring objects at the center of the image into sharp focus.

Especially good for	Availability	Tips
People	UNCOMMON	Many camera phones without selectable metering use this automatically.
People, Nightlife	UNCOMMON	A good tool for dealing with extremes of brightness.
Nightlife, Outdoors	UNCOMMON	Most camera phones control ISO automatically. The higher the ISO, the more image noise will be produced.
People, Products, still life, and documents	RARE	Use the lowest f-stop available to create a blurred background effect.
Sports, Performances	RARE	Use a shutter speed of 1/250 second or higher to capture sharp images of fast-moving subjects.
All Types of Pictures	RARE	Don't forget to choose the best ISO setting when using manual exposure.
Buildings and interiors, People	UNCOMMON	Choose 50Hz or 60Hz cancellation according to the electrical voltage used where you're shooting. In most countries, 120 volts correspond to 60Hz and 220 volts to 50Hz.
Landscapes, Buildings and interiors, Street scenes and news	RARE	Usually available only in review mode.
All Types of Pictures	UBIQUITOUS	Read up on why you should use digital zoom judiciously in the Rules of Thumb.
Landscapes, People, Documents, Buildings and interiors	UNCOMMON	Using the Rule of Thirds is one of the Rules of Thumb.
People, Products and Documents, Street scenes and news, Landscapes, Buildings	UNCOMMON	Using autofocus usually increases shutter lag, especially in low light.

Feature	Typical icon or abbreviation	What it does
Infinite	∞	Sets the lens to capture as much of the image as possible in focus, including the most distant points.
Macro	✿	Adjusts the lens so that very nearby objects can appear in focus.
Manual	MF	Allows you to adjust focus manually, usually with a graphical slider.
Image stabilizer	🕱	Reduces blurring caused by hand motion.

COLOR

Feature	Typical icon or abbreviation	What it does
Automatic white balance	A	Automatically attempts to make colors look natural when illuminated by any type of light.
Sunny (aka Daylight) white balance	☼	Adjusts color balance to make colors look natural under bright sunlight.
Cloudy white balance	☁	Adjusts color balance to make colors look natural in overcast conditions.
Tungsten (aka Incandescent or Bulb) white balance	♈	Adjusts color balance to make colors look natural under tungsten incandescent lighting.
Fluorescent white balance	▥	Adjusts color balance to make colors look natural under fluorescent lighting.
Custom white balance	◣	Allows you to set the color balance manually for a specific light source.

Especially good for	Availability	Tips
Landscapes, street scenes and news	UNCOMMON	Camera phones without focus controls generally use a fixed infinite focus.
Products, still life, and documents	UNCOMMON	Will probably reduce your depth of field, so it's not always the right choice for products and documents.
People, Products, still life, and documents, Out in the elements	RARE	A good choice when shooting through glass or another reflective surface.
Sports, Nightlife, live music, and performances, Out in the elements	UNCOMMON	May reduce resolution slightly, but it's usually worth the tradeoff.
All types of pictures	UBIQUITOUS	Especially helpful with mixed natural and artificial light.
People, Landscapes, Buildings, Out in the elements	UNCOMMON	May work well with a slave flash.
People, Landscapes, Buildings, Out in the elements	UNCOMMON	May work well with some daylight and full spectrum bulbs.
People, Interiors, Nightlife, Products, still life, and documents	UNCOMMON	May work well with halogen lighting.
People, Interiors, Products, still life, and documents	UNCOMMON	There are different types of fluorescent lights; some camera phones offer more than one fluorescent setting.
People, Nightlife, Products and still life, Buildings and interiors	RARE	To set custom white balance, take a picture of a white surface under the the lighting that will illuminate your images.

Feature	Typical icon or abbreviation	What it does
SCENE MODES		
Night	☾	Increases exposure to make the image brighter in low light.
Portrait	☺	Automatically optimizes exposure, color, contrast, and other parameters for portraits.
Landscape	△	Automatically optimizes exposure, focus, color, contrast, and other image parameters for landscapes.
Twilight Landscape	△	A Night mode with no flash available.
Twilight Portrait	☺*	A Night mode with flash to illuminate nearby subjects.
Sports	🏃	Automatically optimizes shutter speed and other parameters for fast-moving subjects.
Portrait Landscape	☻	Automatically optimizes exposure, focus, color, contrast, and other parameters for portraits that include ample background areas.
Document (aka Text)	▤	Automatically optimizes exposure, focus, contrast, and other parameters for printed text.
Beach and Snow	8	Automatically optimizes exposure, color, contrast, and other parameters for brightly lit images with large white areas, such as those taken on a beach or snowy area.
Backlight	none	Automatically optimizes exposure and other parameters for subjects with a bright light behind them.
Daylight	none	Automatically optimizes exposure, color, contrast, and other parameters for images taken in open sunlight.

Especially good for	Availability	Tips
Nightlife, live music, and performances, Interiors, Street scenes and news	UBIQUITOUS	Can be useful even in moderately dim lighting.
People	COMMON	
Landscapes, Buildings and Interiors	COMMON	
Landscapes, Buildings and Interiors	UNCOMMON	
People, Nightlife	UNCOMMON	
Sports, Live music and performances, Street scenes and news	UNCOMMON	
People, Street scenes and news	UNCOMMON	
Documents	UNCOMMON	
Out in the elements	UNCOMMON	
Nightlife, live music, and performances, People	UNCOMMON	
Landscapes, Out in the elements, Buildings	UNCOMMON	

Feature	Typical icon or abbreviation	What it does

FLASH AND VIDEO LIGHT

Feature	Typical icon or abbreviation	What it does
Automatic Flash	A⚡	Automatically fires the built-in flash when room or natural lighting is low.
Always On	⚡	Fires the built-in flash with every shot.
Always Off	⊘	Disables the built-in flash.
Only This Shot	none	Fires the built-in flash with one shot and then disables it.
Redeye Reduction	👁⚡	Fires a pre-flash before the main flash exposure to make your subjects' pupils contract.

SEQUENCES AND SHOT TIMING

Feature	Typical icon or abbreviation	What it does
Self-timer	⏲	Delays image capture for a designated number of seconds after the shutter release is pressed.
Sequence (aka Burst or Multishot) mode	▤	Captures a series of shots when the shutter release is pressed and held.
Sony Ericsson BestPic	▭	Captures a very quick series of nine shots when the shutter release is pressed, then lets you select the frames to save.
Panorama mode	▦	Helps you align a series of photos with an LCD guide, then stitches them together to create one image.
Automatic Exposure Bracketing	▤	A sequence mode that captures successive frames with exposure that is automatically calculated to be proper, slightly dark, and slightly bright.

Especially good for	Availability	Tips
People, Nightlife, Interiors, Out in the elements	COMMON	May extend the delay between shots.
People, Nightlife, Interiors, Out in the elements	COMMON	May extend the delay between shots.
Landscapes, Products, still life, and documents	COMMON	Turn the flash off if you need to conserve battery life.
People, Nightlife, Interiors, Out in the elements	UNCOMMON	Causes a longer shutter lag.
People, Nightlife	UNCOMMON	
People, Landscapes, Buildings and interiors, Products, still life, and documents, Nightlife	COMMON	Usually available with 2, 3, 5, 10, or 20 second delays.
Sports, Nightlife, live music, and performances, People	UNCOMMON	Some sequence modes save multiple images in one frame, while others save a series of whole frames.
People, Street scenes and news, Sports, Nightlife, live music, and performances	UNCOMMON	Useful for capturing sequences of very fast movement.
Landscapes, Buildings and interiors	UNCOMMON	Some panorama modes let you align and stitch photos both side-by-side and from top to bottom.
People, Landscapes, Out in the elements	RARE	Try this when you don't have time to make exposure adjustments for each shot but don't trust the automatic exposure to get it right.

Feature	Typical icon or abbreviation	What it does
EFFECTS		
Contrast	◐	Lets you increase or decrease image contrast, usually with a graphical slider.
Brightness (aka Light Balance)	☼	Lets you increase or decrease image brightness, usually with a graphical slider.
Auto Level (aka Autocorrect)	⬚	Automatically optimizes the brightness and contrast of an image.
Saturation	none	Lets you increase or decrease color saturation, usually with a graphical slider.
Sharpness	none	Lets you increase or decrease color sharpness, usually with a graphical slider.
Blur	none	Lets you blur the image, usually with a graphical slider.
Color effects	none	Lets you convert the image to black and white (aka monochrome or gray) or sepia (aka antique or old film), or apply a color tone such as blue, red, green, or purple.
Art and photo media effects	none	Applies an effect such as solarize, negative, sketch, frosted glass, painting, cartoon, mosaic, pencil, conte, posterize, wood cut, emboss, or neon.
Looks	none	Applies a combination of effects to create a particular look with an evocative name such as milky, dawn, creamy-charismatic, or horror
Distorting effects	none	Distorts the image to create looks such as thin or river reflect

Especially good for	Availability	Tips
Documents, Landscapes	UNCOMMON	Increase contrast to make documents easier to read.
Landscapes, Nightlife, Out in the elements	UNCOMMON	To capture colored lights at night, try underexposing the shot and increasing brightness later.
Landscapes, Nightlife, Out in the elements	UNCOMMON	A few camera phones will display before and after images of this and other effects.
Landscapes, Nightlife, Products, still life, and documents	UNCOMMON	Try lowering saturation as a special effect.
Street scenes and news, Sports, Buildings and interiors, Products, still life, and documents	UNCOMMON	Increasing sharpness will also increase the appearance of image noise.
People, Sports	UNCOMMON	Try using blur to emphasize gestures and movement instead of details.
People, Landscapes, Nightlife, live music, and performances	COMMON	You can make a copy of a full-color image and apply an effect, but you can't restore an original image captured with the effect to full color.
People, Street scenes, Nightlife, live music, and performances, Still life and documents	COMMON	A "negative effect" is useful for photographing documents with light text on a dark background.
People, Street scenes, Nightlife, live music, and performances, Still life and documents	COMMON	If you find yourself applying the creamy-charismatic or horror effects a lot, get help.
People, Landscapes, Still life	UNCOMMON	If a closeup image looks distorted, try applying a thin effect to make it look more natural.

Feature	Typical icon or abbreviation	What it does

EDITING

Feature	Typical icon or abbreviation	What it does
Crop	✣	Lets you save a portion of the image as a separate photo.
Rotate	↻	Rotates the image 90 degrees.
Flip	▸◂	Flips the image 180 degrees.
Resize	▣	Saves the image at a reduced resolution.
Trim	✄	Allows you to clip the beginning or end of a video by selecting start and end points.
Redeye removal	👁	Colors red pupils dark gray for a more natural look.
Transitions	none	Applies an effect to the transition between photos in a slide show or sections in a video clip; options include wipes, fades, slides, and crosses.
Add	none	Lets you add text, photos, graphics, soundtracks, and frames to photos, slideshows, and videos.
Merge	none	Lets you make a composite of two or more images.
Copy and Paste	none	Lets you copy a portion of one image and paste it onto another.

Especially good for	Availability	Tips
Products, still life, and documents	COMMON	If you can't get close enough to a small object to keep it in focus and fill enough of the frame for good composition, consider cropping.
Products, still life, and documents	COMMON	Shoot with the orientation that permits the best composition, then rotate for display if necessary.
People, Products, still life, and documents	UNCOMMON	Sometimes flipping an image horizontally makes the composition look more appealing.
All types of pictures	UBIQUITOUS	Useful for making small copies to send via MMS or e-mail.
Nightlife, live music, and performances, Street scenes, People, Sports	UNCOMMON	Some camera phones let you trim individual video segments, then stitch them together into one clip.
People, Nightlife	UNCOMMON	Redeye removal tools occasionally produce black spots on lips.
Nightlife, live music, and performances, Street scenes, People, Sports	UNCOMMON	Try to use a transition that echoes, punctuates, or complements the motion in the scene.
People, Documents, Street scenes, Live music and performances	COMMON	Try capturing sound at an event with a separate MP3 recorder, loading it onto your phone, and adding it to the event slideshow or video.
Landscapes, People	UNCOMMON	Try merging two shots from a sequence to show motion.
Interiors, Products and documents	UNCOMMON	Try using this to inset a detail shot.

ACCESSORIES FOR 99 CENTS OR MORE

There's a store in my neighborhood with a big sign advertising "Everything 99 Cents or More!" Camera-phone accessories fall into that same price range, with plenty at the low end of it. After all, if your phone was free from your service provider, you might not want to shell out a lot of cash for accessories. On the other hand, if you're just waiting for an excuse to spend some serious money on a new gadget, this list should accommodate you as well. Either way, adding a few accessories can make your camera phone more useful and versatile than you thought possible. And all of these tools and gadgets share the virtues of the camera phone itself: They're compact, lightweight and easy to carry. I've included listings of companies that make or distribute each type of accessory. These listings are not exhaustive, but they'll show you where to start looking for options.

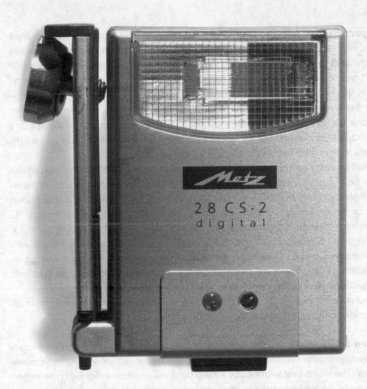

LIGHTS

Camera-phone lights If your camera phone doesn't have a flash or you want to supplement the built-in flash, purchase a single-LED light that clips onto a keychain or a belt loop. LEDs provide continuous illumination, so you can use them for both photos and videos. A single LED provides a limited amount and range of light, so it's best used with nearby subjects and small objects it can illuminate completely. You can also buy small LED flashlights with more than one LED for greater illumination. If you're photographing small objects, an LED ring light can illuminate them evenly. Clamp it to a support or hold it over the object, then position your camera-phone lens behind the center of the circle of light.

Compact flashes, triggers and video lights If you have a built-in flash but want a lot more light, try a compact slave flash. They're called slaves because they take orders from the flash in your camera phone. When it fires, the slave fires simultaneously. It doesn't need to be physically connected to the phone flash. It's often a good idea to use only the external flash so you eliminate the harsh, dead-on light from the camera-phone flash and don't create weird shadows because of light coming from different directions. To do this, buy slide film and have it developed without exposing it. Cut a little piece out and tape it over the camera phone's flash. It will block most visible light but allow in enough infrared light to trigger the slave flash.

You'll probably have to take a test shot and adjust your exposure when you use this type of flash since your camera phone won't take the external flash into account when it automatically calculates exposure. If you want to use an external flash you already own with your camera phone, purchase a slave trigger that attaches to the hotshoe or PC sync connector on the flash. These work with many external flashes, making them fire when triggered by your camera-phone flash. Look for one that's explicitly for use with digital cameras. Compact slave flashes come in a variety of clever forms. In addition to small, handheld units, there are those that screw into and are powered by light-bulb sockets, others with suction-cup mounts, and others that are waterproof.

If you need more light for video, buy a compact, battery-powered video light, which will provide continuous illumination.

Infrared lights An infrared flashlight can be used with many camera phones to capture an image in total darkness — or when the light level is just too low for the camera to handle. This works best with nearby subjects and will produce a monochrome image. The range of infrared-light wavelengths commonly emitted by infrared flashlights runs from about 750nm to 1000nm. It's best to use a light that's close to the bottom of this range, because the higher you go, the weaker the illumination. If you go very low, you'll be able to see a faint, red glow coming from the light. It's essential to get a light with a wide beam, otherwise you'll see just a small spot of visible image within the frame. Infrared flashlights with multiple LEDs work well for this reason. Make sure you can try the light out with your camera phone before you buy it, or make your purchase from a source that will give you a refund if it doesn't work.

Light sources:
Achiever www.achiever.com.hk: compact slave flashes
Bescor www.bescor.com: compact video lights
CameraBright www.camerabright.com: camera phone LEDs

Canon www.canon.com: compact slave flashes and video lights

Foxden Holdings www.phonephlash.com: camera phone LEDs

Greenbulb www.greenbulb.com: camera phone LEDs

LDP www.maxmax.com: infrared flashlights

Metz www.metz.de/en: compact slave flashes

Novoflex www.novoflex.de/english: compact slave flashes

Sea and Sea www.seaandsea.jp: waterproof slave flashes and video lights

Sealife www.sealife-cameras.com: waterproof slave flashes

Sima www.simaproducts.com: compact LED panels, compact video lights

Sony www.sony.com: compact video and infrared lights

SP Studio Systems: socket-mounted, suction-cup-mounted and other compact slave flashes; slave triggers

SR Electronics www.srelectronics.com: compact slave flashes and LED ring lights

Sunpak www.tocad.com/sunpak.html: compact slave flashes and video lights

The Morris Company www.themorriscompany.com: socket-mounted and other compact slave flashes

Vivitar www.vivitar.com: compact slave flashes

Weln www.weinproducts.com: slave triggers

Light tents Light tents are used to create even lighting when taking still life and product photos. They're especially handy for lighting shiny objects without creating bright reflections. The object is surrounded by a translucent white material, which diffuses lights placed outside the tent. You can build your own tent with a frame made of wood, metal or PVC. There are plenty of examples of homemade light tents on the Web.

Here's my own homemade light-tent design for small objects. You can purchase all the materials for less than $20. You'll need:

A WHITE CHINESE LANTERN ABOUT 2 FEET IN DIAMETER

TWO ROLLS OF WHITE PAPER TOWELS

SOME CLIPS OR BOBBY PINS

A THICK PIECE OF PAPER ABOUT 11X14 INCHES (E.G., POSTER BOARD OR INKJET-PRINTER PAPER)

Take almost all of the paper off two paper-towel rolls and put them inside the lantern vertically, clipping them to the wire of the top and bottom openings. This will hold the lantern open. Put a thick piece of paper inside the lantern so it covers part of the bottom and one side, forming a curved background. Put a light to each side of the

lantern, put your object on the paper, and reach in with your camera phone to take the shot. Make sure you don't cast an unwanted shadow with your hand. You can shoot objects from above or turn the lantern on its side for frontal shots.

If you do a lot of product photography, consider buying a professionally made tent. Ready-made tents use high-quality fabric, and many are collapsible for easy transportation and storage.

To prop up, position or affix objects inside a light tent or on any background, you can use the kind of tack putty sold in office supply stores, or you can buy museum gel, wax, or putty.

Light tent and museum putty sources:
EZCube www.ezcube.com
Interfit www.interfitphotographic.com
Lastolite www.lastolite.com
Photek www.photekusa.com
Photoflex www.photoflex.com
Smith Victor www.smithvictor.com
Pearl River www.pearlriver.com: Chinese lanterns
Trevco QuakeHold http://quakehold.com: museum gel, wax, and putty

Waterproof cases
You can take your camera phone snorkeling, skiing, or into very dusty environments in a waterproof case. Some cases are just fancy Ziploc bags that might make it difficult to use camera controls, but others are designed so you can take pictures more easily. Camera-phone cases aren't made to resist water pressure, so don't dive too deep with them. You can also buy waterproof flashlights and a colored lens gel to compensate for the blue color cast underwater (see filters). Pick up a little pack of desiccant to put in the case to absorb any moisture that might condense inside.

Waterproof-case sources:
Aloksak www.watchfuleyedesigns.com
Aquapac www.aquapac.net
Ewa-marine www.ewa-marine.com
Kwiktec Dry Pak www.drypakcase.com

GPS receivers If your camera phone is equipped with an internal GPS receiver, go straight to pages 115-116 to find applications that will let you add location information to your pho-

tos; and read more about geocoding. Peripatetic camera-phone photographers who don't have built-in GPS but still want to geocode their shots will need a separate GPS device. If you have a phone that has Bluetooth and a platform that's compatible with mobile geocoding software, look for a GPS receiver equipped with Bluetooth so you can send the GPS data straight to your phone.

GPS receiver sources:
Garmin www.garmin.com
Holux www.holux.com
Lowrance www.lowrance.com
Magellan www.magellangps.com
Pharos www.pharosgps.com

Sony www.sony.com
Tomtom www.tomtom.com
USGlobalSat www.usglobalsat.com

Lenses and magnifiers A few companies make telephoto and wide-angle lenses that mount over your camera phone's built-in lens. Their quality varies, ranging from cheap, plastic lenses that stick to the camera phone with adhesive to glass optics that mount (usually magnetically) on a base permanently attached to the camera phone. These work with camera-phone designs that have some surface space around the lens, to which the mount can be affixed.

A magnifying glass can come in handy for taking closeups of small objects, and camera-phone lenses are so tiny that a small, inexpensive magnifier will provide adequate coverage. A pop-out magnifier is convenient to carry in a pocket or purse and also more easily propped up in front of an object to leave your hands free for shooting. Some pop-out magnifiers are equipped with lights.

You can also purchase the type of closeup lens that screws onto a camera lens and simply hold it in front of your camera phone. If you feel like experimenting, you can buy unmounted glass or plastic lenses and hold them over your camera-phone lens or mount them with Velcro or double-sided tape. Use rigid plastic tubing to create a barrel that will hold the lens the right distance from the camera phone to get things in focus.

Camera phone lens and magnifier sources:
Amacrox www.amacrox.com: magnet-mounted lenses
American Science and Surplus www.sciplus.com: unmounted lenses
Brando http://mobile.brando.com.hk: plastic stick-on lenses and mountable "telescope"
Crystal Vision: magnet-mounted lenses
Cokin www.cokin.com: magnet mounted lenses
Sima www.simaproducts.com: plastic stick-on lenses
Optics Planet www.opticsplanet.com: magnifiers and other optics

Tripods and supports It's highly unlikely that you'll carry a big tripod around with your camera phone; but you might find it worthwhile to bring a compact camera phone tripod along on trips or to special occasions. Camera-phone tripods are essentially tabletop tripods with some type of clip or mount that will hold a camera phone.

The main advantages of putting your camera phone on a tripod are that it will eliminate blurring caused by the movement of your hand, allow you to include yourself in self-timer shots, and let you keep the image framed the same way for multiple shots. However,

camera-phone tripods aren't very stable since they're so lightweight. A little wind might cause vibrations that will blur your photos, or even blow the tripod right over. To make your camera-phone tripod more stable in the wind, carry a Ziploc bag inside a mesh bag with a hook or clip on it. Fill the Ziploc with water, sand or rocks, and hook it to the tripod so it hangs down from the center. If the tripod is too small for this, simply carry some string so you can tie a suitably sized rock to the center of the tripod as a weight.

Another way to stabilize your camera phone is to buy a rigid holster with a clip on the back so you can clip your phone to a stable object. You can find inexpensive, generic versions of these at most cellphone stores and online. Some companies also make a variety of clip types, including magnetic mounts. Make sure you can operate the camera phone when it's in the holster.

Camera-phone supports:
Joy Innovations www.joyinnovations.com: tripods
Krusell www.krusell.se: holsters and clips
Sunpak www.tocad.com/sunpak.html: tripods
Sima www.simaproducts.com: tripods

Filters You can't attach a standard lens filter to a camera phone; but you may be able to find a cheap stick-on filter at an electronics store or you can just hold a regular filter in front of the lens. Carrying a polarizer in your pocket is a good idea because it will cut glare in bright conditions, increase contrast and color saturation, and allow you to take photos through glass or water. Polarized sunglasses will also work. Make sure you hold the filter as close to the lens as possible to avoid bouncing light between the lens and the filter.

If you're taking your camera phone underwater, try taping a piece of CC30R gel over the lens before you put the device in an underwater case. It's the same color as a standard underwater filter and will compensate for the blue cast of underwater light to restore a more natural look to warm-toned objects such as coral or fish.

There are hundreds of color and special-effects filters available to those who want to experiment.

Filter sources:
Hoya www.thkphoto.com: filters
Kenko www.thkphoto.com: filters
Kodak www.kodak.com: polarizers, filters and gels
Lee Filters www.leefilters.com: filters and gels
Opti-flex www.visualdepartures.com/optiflex.html: filters and gels
Sunpak www.tocad.com/sunpak.html: filters

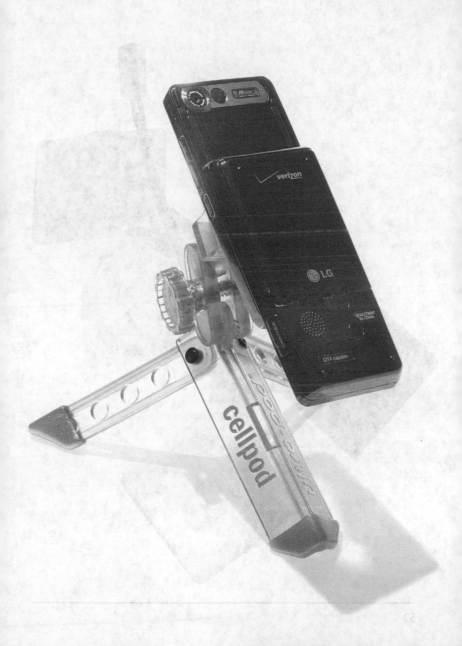

Tiffen www.tiffen.com: filters

More expensive, high-quality filters to consider if you'll also use them with a dedicated camera:

B+W www.schneideroptics.com:
Heliopan www.hpmarketingcorp.com/heliopan.html

Viewing aids If you're shooting in very bright light, it can be hard to see the image on your camera phone's screen. An LCD hood will shield the screen from direct light. Make your own with four pieces of cardboard taped together and attached to your camera phone with a rubber band. You also can buy LCD hoods that attach to your camera phone with a strap. Some incorporate eyepiece viewers to keep more ambient light off the screen and give you a better view. An LCD loupe provides a magnified view of the screen and allows you to adjust the focus of the eyepiece if your vision isn't 20/20.

If your phone doesn't already have a self-portrait mirror next to the lens, you can buy a convex stick-on mirror for it.

LCD hood and loupe sources:
Delkin www.delkin.com
Hoodman www.hoodmanusa.com
Photodon www.photodon.com

Stick-on mirror sources:
Greenbulb www.greenbulb.com

Portable chargers Taking photos and videos can drain your phone's battery quickly. If you're away from an outlet, charge the battery with a solar or car charger. You can even buy bags with incorporated solar chargers. For emergencies, use an inexpensive hand-cranked charger. If you're planning to travel and don't want to bring several chargers along, consider buying a multiple-device charger. Some include both A/C and car connections.

Portable charger sources:
Boxwave www.boxwave.com: multiple-device chargers
PowerFilm www.powerfilmsolar.com: roll-up and foldable solar chargers
Sidewinder www.sidewinder.ca: crank chargers
Sima www.simaproducts.com: crank flashlight with charger
Soldius www.soldius.com: solar chargers and charging bags

If you have a camera phone, you've probably located its shutter release and mastered the hold-it-up-and-push-the-button shooting technique. But there are many more options than that in camera-phone photography and videography. Getting to know the settings, techniques and accessories available can help you capture more compelling images and have a better time doing it. In some ways, taking pictures with a camera phone is no different from using a dedicated digital camera or a camcorder. General rules and shooting techniques apply to any image-capture device. However, camera phones have their own particular strengths and weaknesses too. The techniques and tools described in this chapter run the gamut from conventional picture-taking wisdom to the peculiarities of mobile imaging.

These rules apply to any kind of shot. They describe

the best basic camera-phone settings to use, guidelines for image composition, ways to compensate for camera phone shortcomings, and useful approaches to photography and videography.

Use the Rule of Thirds When composing a picture, imagine two horizontal lines and two vertical lines crossing like a tic-tac-toe grid on top of it. Place strong lines and divisions like the horizon in your image on the gridlines and let elements of interest fall on the intersections. A few camera phones let you activate a grid display on the image-preview screen. You can also make your own grid display on a transparent LCD skin with a felt-tip pen. Another option is software that creates a composition overlay in an image-editing program so you can crop your image to conform to various compositional principles (see the Software Toolbox).

Stabilize your camera phone Image-stabilizing functions are now common in compact digital cameras. If your camera phone has a stabilizing feature for video or photos, use it. Camera phones are so lightweight it's nearly impossible to keep them steady and avoid blurred images.

This problem gets worse in low light, since the camera phone slows the shutter speed to let in more light and has a longer opportunity to capture movement. To ameliorate this problem, hold the camera phone with both hands and brace your upper arms against your body when you shoot. Bracing your hand against an immobile object such as a telephone pole or a tree can also help, as can a tripod (see accessories) or other support. For posed shots, the self-timer will help keep you from tilting the phone when you push the shutter-release button.

Use the highest resolution setting Unless you're sure the only thing you want to do with your images is send them to another mobile device or post them online, use the highest resolution setting available. If later you want to print a shot, you'll be glad you did. When shooting video, a higher resolution shows more detail and allows a larger image display when playing the video

on a computer screen. If your camera phone has a memory-card slot, use a high-capacity card so you won't have to drop the resolution to save space. If the phone is compatible with software that lets you upload your images to a gallery or moblog at full resolution, use that to make room on your memory card instead of sacrificing image quality.

Use the highest quality setting Most camera phones allow you to select a quality level for your images. This determines the level of compression used when the images are saved. The higher the quality setting, the lower the compression level. Choose the highest quality setting available so you lose less detail and don't get a muddy photo. If you have to choose between resolution and a quality setting to save space — and it's unlikely you'll make prints — reduce the resolution. Even VGA or QVGA resolution will look fine on a screen, but using heavy compression will make the image look worse in any form of display.

RULE OF THIRDS: Envision your picture with a tic-tac-toe-like grid on top to help you compose your photographs in a more compelling way. Place interesting details on the intersections, as below.

5 **Shoot videos at the right frame rate** If your camera phone gives you a choice, use the highest frame rate available for videos, unless you want a slower rate for effect. The most advanced devices can shoot at 30 frames per second— the same rate used by most digital camcorders. Some shoot at a rate closer to 24 frames per second, the rate used to shoot most movies on film. Dropping down to about 15 frames per second gives choppier footage with a look similar to that of an old, silent movie. Higher frame rates produce a smoother look but take up more memory; so if your camera phone has a memory card slot and you're going to shoot a lot of video, get a high-capacity card.

6 **Use a low ISO setting if you can** Many camera phones don't let you control the ISO setting; but if you have one that does, make use of it. In good light, set the ISO to a low number, like 100. The lower the number, the less visual noise will appear in your images. As the light level drops, increase the light sensitivity of the sensor by using a higher ISO setting or switch to auto ISO. You'll get noisier photos at higher ISO levels, but sometimes that's better than no photos at all.

Get the right color tone Most camera phones provide a handful of white-balance settings, along with some color effects like black-and-white and sepia. Check the Camera Phone Rosetta Stone for information about what each setting does. In general, it's a good idea to notice what kind of light you're shooting in and select color settings accordingly. Using a white-balance setting designated for the type of light in your scene often produces more natural-looking results than automatic white balance, especially with fluorescent lighting. If the lighting is mixed— maybe incandescent bulbs and natural light from a window— you're better off using automatic white balance. Take a few test shots to see what works. If the light is very dim and there's a lot of visual noise in your shots, try a monochrome shooting mode or convert your shots to black-and-white or sepia with an editing tool. The speckles that look ugly in color can give an image an atmospheric, grainy look in shades of gray or sepia. Shooting in black-and-white in any light can help develop your photographer's eye by letting you concentrate on the relationship between light and shadow without the distraction of color.

8 **Use digital zoom judiciously** A limited number of camera phones offer optical zoom, giving you more flexibility in composing your shot. There's no reason not to use it. Almost all camera phones are equipped with digital

zoom, which it's usually not a good idea to use. A digital zoom is basically a cropping function that cuts out and saves a portion of the image that is optically available to the sensor — and ultimately degrades its quality. Whenever possible, opt for sneaker zoom: Take a few steps back or forward to change the framing instead of using a digital zoom or having subjects move.

There may be times when composition is more important than quality — maybe if you're shooting video of a speaker and want the speaker's head and upper body to fill most of the frame. In any case, you won't see the person's face very clearly; but if you use the digital zoom, the image will be composed well. Just remember that digital zoom will negatively affect the quality of both photos and videos, and use it only when the alternative is worse.

Anticipate shutter lag If you've ever used a compact digital camera, you're familiar with shutter lag. It's the delay between the moment you press the shutter-release button and the moment the image is captured. In very simple camera phones, there's a negligible delay. More sophisticated devices, however, are prone to noticeable shutter lags, especially with autofocus. Get used to your camera phone's timing so when something interesting happens, you'll have a good feel for the point when you need to press the shutter release to capture the most interesting moment.

Decide what your photograph is about before you take it If you're taking a picture or shooting a video, think about the story your photo or video will tell before you take it. What is the main subject of the photo? What are you trying to convey about it? Which elements of the scene help you tell the story, and which are footnotes and tangents better left out? Ask yourself what it is about what you see that makes you want to take a picture of it, and think about the best way to show that to someone who sees the picture.

Go to eleven Pay attention. There are times we all just want to hold the camera up and push the button. But when you want the best image, take a good look at your subject and your lighting. Consider how they work together; what is visually interesting about them, and how the tools at your disposal can be used to create a more compelling image. Taking a good photograph or video is about providing insight; and that's something technology will never automate.

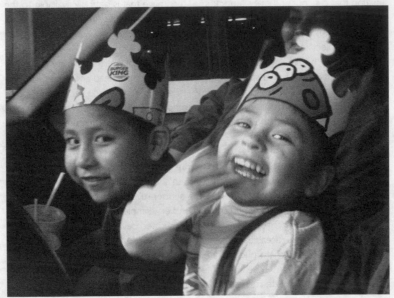

MOVE IN CLOSER TO YOUR SUBJECT: When the background of your picture is cluttered and the lighting is questionable, fill the frame of your camera phone by moving in closer to your subject.

You don't have to be a market researcher to figure out that most of the photos people take with camera phones are of ... people. These techniques will help you do your human subjects justice. Most of them work well for pets, too.

Stay at arm's length Filling the frame with someone's face is an easy way to avoid bad composition. However, most camera phone lenses are prone to barrel distortion making the person's face look like a reflection on a shiny doorknob. To avoid this effect, keep the camera an arm's length from your subject. If you want to get up close, photograph the person from a three-quarter angle or a slightly higher angle rather than a

straight-on shot or a low-angle shot. For videos, make sure you're close enough to your subjects to capture their voices clearly.

Choose the right frame orientation A vertical orientation often works best when taking a picture of just one or two people. It allows you to fill more of the frame with the people and not extraneous background elements. However, if you want to show some of your subjects' surroundings, horizontal orientation is better. Just remember the rule of thirds. Positioning one or two people off-center in a horizontal shot almost always makes a stronger photograph than putting them right in the middle. For videos, always use horizontal orientation, since that's how video is displayed. Frame your subject's face slightly off center, leaving a little space above the head.

Find the right angle Each subject warrants a careful look at the angle you intend to use. When photographing children or pets, for example, you can make better pictures if you get down low and shoot at their level instead of holding the camera above them. When photographing adults, experiment with both the angle of your composition and the angle of light to see what's most flattering. Place a light from a window or a lamp to one side of a person's face to create a dramatic effect. Angle the light 20- to 45-degrees towards the person's face to give it more dimension. If you get harder shadows than you want, try diffusing the light with a shade or some translucent white fabric. Avoid photographing a person dead-on with a built-in flash. That produces a flat look and is rarely the most attractive photo option.

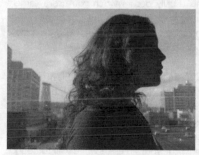

BOUNCE LIGHT ONTO YOUR SUBJECT: When your subject is in shadow, don't be afraid to bounce any kind of light off the ceiling or nearby wall (white or a light color is preferable) to help your photo.

Bounce the light If the face of your subject is suffering from light and dark patches created by irregular light, you can bounce sunlight, a hand-held flash, or a light (such as a goose-

neck lamp) into the dark areas by angling a large white card so the light hits the card and bounces onto your subject. Experiment with the angle so the light can illuminate evenly. If you're indoors where there's a white ceiling, point a strong light or a hand-held flash at the ceiling to create a more flattering light than pointing the light directly at your subject.

Avoid direct sunlight Your subjects will be cooler, happier and more attractively lit if they don't have a sunbeam hitting them in the face. If it's an overcast day, you're in luck. This is one of the best outdoor lighting situations for photographing people. If it's a sunny day, have your subjects stand in the brightest patch of shade you can find. The goal is to get away from harsh light while avoiding areas that are too dark, which can increase the amount of visual noise in the picture.

Keep an eye on background objects Distant objects behind a person can appear much closer in a camera-phone photo because the cameras tend not to have the depth of field range you have in a digital camera. Space looks compressed. Avoid including background objects that are the same height as your subjects and might compete for attention with your subjects' faces. Don't allow objects to jut out of someone's head in the background. If you want a blurred-background look, you can use a blurring tool in image- editing software to soften the background. Another option is to use the technique of panning, as described in the section on shooting sports.

One pitfall to avoid is having a completely black background that makes your subjects look like they're floating in space. This usually occurs when you use a camera phone's built-in flash in a dark area. Switching your phone to a night portrait mode often solves the problem. A hand-held flash can also help, although if you get too close to your subject with it, your subject will be overexposed.

Step away from the wall You may think that a wall could serve as a plain, unobtrusive background, and that would be true if the wall were illuminated with bright lights the way photographers do in a studio. But chances are it's not, and the result will be a lot of dark shadows cast on the wall, especially if you use a flash. Have your subjects stand far enough from the wall to minimize harsh shadows.

If you have an off-camera flash or a bright light, you can use a white wall to bounce the light. Stand with your back to the wall and your group in front of you so that they fill the frame, and point the light or flash at the wall behind you. The wall will serve as a big reflector, casting a flattering, even light onto your subjects. If the wall isn't white but is a light color with a warm tone, you're probably safe, but avoid bouncing off of blue or green colors. They'll probably make your subjects look a little ill.

BREAK THE RULES: The old rule about keeping the sun behind you while you take a picture is no longer applicable thanks to instant review capabilities on your LCD screen. Experiment and enjoy.

Feeling lazy? Look for a camera phone that incorporates software that will do half the work for you. The digital-imaging technology innovators at FotoNation have created face-tracking software that automatically detects faces in a scene and tracks them as they move within the frame. When you take your shot, the software optimizes exposure, focus and color settings for the faces it has detected. Face Tracker can track as many as eight faces at the same time.

Adjust exposure for groups with different skin tones Camera phones are not very adept at capturing a broad range of light and shadow in one shot. That can be a problem when you're photographing a group of people with varying skin tones. Try to position people with darker skin tones closest to the light source for your photo or in the best-lit area of an outdoor scene. If you're using an on-camera flash, put people with darker skin tones closest to the camera. Use the exposure compensation feature on your camera to adjust the brightness of the image on the LCD until it looks like everyone's face is reasonably well-exposed.

Use backlighting to your advantage Sometimes backlighting can be used to good effect. If a light is directly behind someone's head, it can illuminate the hair and create a halo effect that sets the person off from the background. Make sure the light isn't shining directly into your lens first. Then use exposure compensation to bump the exposure up so the person's face isn't too dark. If your camera phone has a spot meter, you can also use that to get the right exposure. Another option is to push things to the other extreme and decrease exposure to shoot a silhouette. If backlighting is very strong, it will probably wash out the background to white, so it's best to try backlighting techniques with a light source that's not too bright.

Use red-eye removal instead of a pre-flash Some camera phones have built-in flash units with a red-eye reduction mode, and many offer a red-eye removal feature that you apply to the photo after you've taken it. Red-eye occurs when the light from an on-camera flash hits your eye and illuminates the blood vessels exposed by your pupil. Camera-phone flash units tend to be very close to the lens, which means the light will hit your eye at nearly the same angle that the lens sees you from, then bounce straight back into the lens. That makes red-eye highly likely to occur. Red-eye reduction fires a burst of light before the flash in order to make your subjects' pupils contract, letting in less light to illuminate blood vessels.

Sometimes it's effective, but most of the time it's annoying to the people being photographed. Red-eye reduction also delays the shot. Red-eye removal, on the other hand, simply finds the red eyes in a photo you've already taken and replaces the red with a charcoal color. In my experience, this technology works well and produces natural-looking results.

STREET SCENES AND NEWS EVENTS

Whether you're interested in street photography for artistic reasons or want to make your images more suitable for news distribution, keeping these points in mind will help you capture the stories played out in public spaces.

Turn off camera sounds and the auto-focus assist lamp If the sound of a shutter might startle your subject, switch it and the auto-focus assist lamp off and set the focus on infinity. The depth of field is large enough on most camera phones that your subject should be in focus unless you get very close.

Don't be shy People usually notice when someone is photographing them, and they might get angry if you're being sneaky about it. Be upfront about who you are and why you're taking pictures. If you're in a foreign country, learn the polite way to address people and try to get information about local photography etiquette before you start snapping. Be prepared to take no for an answer occasionally. There will be other pictures.

Capture context Remember the essential news questions – who, what, when, where, why and how – and try to answer as many as possible with your image. Try to make it clear what the subject is doing and with whom. When shooting a building or an object, try to include nearby elements that indicate its location or environment. Make sure the calendar and clock on your camera phone are set correctly so the images you capture will be tagged with accurate information.

Don't zoom and reframe a lot in video Frame

AUTOMATIC STREET PHOTOGRAPHY

If you're looking for a new approach to street photography, want to know what's happening behind your back when you're strolling around, or are just plain lazy, check out WayMarkr (http://waymarkr.com). It's software that will take pictures for you while you're window shopping. When you activate it on your camera phone, WayMarkr captures a continuous stream of photos and sends them to your account on the WayMarkr Web site. You'll get the best results if you strap your camera phone to your body or a relatively stable object with you, so it doesn't jiggle around. On the Web site, you can make your images public or link them to a map showing where they were taken. To use Waymarkr, you'll need a compatible camera phone and a data-service plan.

your subject and keep the framing until it doesn't work anymore, then try to reframe by zooming or moving the camera just once. If your subject is moving, try to follow the motion with your camera phone, keeping the subject in the same spot on the LCD. Keeping the frame still and letting your subject walk into or out of it can also work.

Ask for names and comments Any news organizations you submit your images to will want the names of people you photograph, and they'll probably appreciate having some information about the people's relationship to the event you're capturing (player in the tournament, witness to the crime, etc.), as well as their ages and occupations. It wouldn't hurt to have a relevant quote to send along too. Use video capture or the phone's voice recorder to gather this information; and ask people to spell their names.

Get good sound People generally tolerate poor image quality more readily than bad sound. If you're shooting video, make sure your subjects can be heard clearly and try to eliminate loud background noises. Shield your microphone from the wind. Try not to make distracting noises or remarks yourself.

Capture B-roll Professional videographers often capture what they call B-roll footage along with the main video. It's generally used at the beginning of a clip or in transitions between different segments of the video to set the scene. So if you're doing an interview on a busy street, take a wide shot of that street for a few moments for B-roll.

Look for a perch If you're shooting an event where there's a crowd or a chaotic situation, try to find a high place to shoot from. It can also be interesting to treat a street scene as a landscape instead of focusing on interactions between people. Shooting from above — or from another unconventional perspective — can shift the viewer's attention to the place itself and away from the individuals who pass through it. This approach can be especially effective with video or with a series of photos that show the changes that occur in a particular location over time.

Use a continuous shooting mode Some advanced camera phones offer a continuous shooting mode that will capture a sequence of photographs when you hold the shutter release down. If you're photographing an animated interaction, a sequence can help tell the whole story. A continuous shooting mode can also be useful when conditions make it difficult to hold the camera steady or maintain an uninterrupted view of your subject.

LANDSCAPES

CREATE A SILHOUETTE: Allow the light meter in your camera phone to measure the light in the sky if you want to make a silhouette of an object in the foreground as Clark did here. Experiment with the different exposure settings in your camera phone as well.

For capturing detail, a camera phone can't compare to the bigger, heavier cameras favored by many landscape photographers. But for convenience, it can't be beat. And while camera phones won't reproduce the finer points in a landscape, you can capture the lay and feel of the land by concentrating on broader strokes.

Put horizons in the right place Keep the horizon straight unless you have a good compositional reason to tilt it. Many people shoot landscapes with a horizontal frame orientation and the horizon near the middle of the image. Sometimes, putting the horizon up high to capture more of the land and surroundings is best. Sometimes, putting the horizon down low to emphasize a dramatic sky is preferable. Both approaches can work

USE NATURAL LINES IN YOUR COMPOSITION:
Fences, roads, rail lines and horizons are just some of the objects
you can use to create interesting compositions in your photography.

well with a vertical frame orientation. Try taking the same shot with the horizon one-third from the bottom of the frame and one-third from the top and see which you like. Be sure to adjust your exposure so the area you're emphasizing shows the most detail.

Add interest with a foreground object Including a nearby person or object in a landscape can make it more compelling visually and provide valuable perspective. Including foreground objects is an especially good idea with camera phones, since they can't capture much detail in far-off areas. Including those objects slightly off-center can often make the shot a winner. If you're using autofocus, focus on the object, hold the shutter-release button down halfway to keep the focus locked on the object, and reframe your image so the object is off to one side before pressing the shutter release all the way.

Wait for the "magic hour" Camera phones don't do a great job of capturing a broad range of dark and light tones in one shot. You'll usually have to choose: either well-exposed land with a nearly blank sky, or a sky that shows some cloud detail but has dark, amorphous land. During the time around sunrise and sunset – what photographers call the "magic hour"— the sky is colorful enough for even a camera phone to capture land and sky with fairly good exposure.

Focus for maximum depth of field Camera phones tend to have great depth of field, so most of your landscape will probably be in focus regardless of the settings you use. Simple camera phones have a fixed focus – you can only point and shoot. If your camera phone is more advanced and allows some control over focus, opt for landscape mode or infinity focus. If you have autofocus, focus one-third of the way into your scene (from the bottom of the frame). You'll get more depth of field behind the point of sharpest focus, so keep that point low in the shot to optimize the image's overall sharpness.

Use converging lines to create depth You can keep a landscape photograph from looking like a cheap, portrait-studio backdrop by including parallel lines that run from the foreground into the background, where they appear to converge in the distance. Roads, canals and rows of crops can work nicely to create a sense of depth and dimension, drawing the viewer's eye into the photograph.

Use diagonals to create a more dynamic image Diagonal lines also work well to create a sense of depth in landscapes. Again, look for a line that begins in the foreground and draws the viewer's eye into the photograph. Elements like fences and rivers are good choices; but if there are strongly contrasting areas of the landscape itself — mountains and

dunes, for example — try framing it so the lines between them create dynamic diagonals.

Shoot a panorama Some camera phones include dedicated panorama modes that help you align three shots side by side and then automatically stitch them together into one file. If not, you can use third-party stitching software on your computer to create panoramas from several frames. A cellphone tripod will help you line up the shots.

Use a polarizer A polarizer is one of the most useful photographic filters. It cuts glare, enhances contrast and color, and reduces the brightness of sunny scenes to make overexposure less likely. If you want to shoot something beneath the surface of a clear body of water or behind a shiny glass pane, a polarizer will reveal it in your photograph. Although you can't mount a filter on a camera phone, you can carry one in your pocket and hold it in front of the lens. (If you wear polarized sunglasses, you already have a filter with you.) Hold the polarizer surface as close as possible to the lens surface to avoid capturing spots of light or hazy areas in your shot.

Combine two exposures The limits of camera phones often leave you with a choice: nicely nuanced land or a richly textured sky. One way around this is to take two pictures and combine them. First, stabilize the camera—ideally with a camera-phone tripod —to keep the frame in exactly the same position for both shots. Compose the shot on the LCD screen so the line between land and sky doesn't have too many tricky curves; then take one shot with the exposure compensation bumped way down for a good sky exposure and one with it bumped up to expose the land. A self-timer can help keep the camera as still as possible. When you get the images home, you'll need a software program that either combines the images automatically or allows you to manually place one on top of the other and erase the dark land in the picture exposed for sky detail.

Control your shutter speed for moving water effects If you want to give a smooth, soft effect to a waterfall or rapids, use a slower shutter speed. For a sharp effect that freezes the action of the water, use a fast speed. If you do have one of the few phones that offer manual or shutter-priority exposure, stabilize it with a tripod or other support and set the shutter speed to 1/30 second or slower for a smooth water effect. Use a speed of 1/250 or higher to freeze the action and show more detail. Sports modes usually increase shutter speed, while night modes slow it down. If you want the smoothest look possible, wait until twilight, use a night mode, and bump your exposure compensation up. This is also a good idea if you're photographing a fountain and want to show the arc of the water.

SPORTS AND ACTION

MASTER SHUTTER LAG: When shooting action, focus your camera phone on the spot the action falls into to counteract shutter delay, the time lapse between pressing the button and the moment the camera takes the picture. Learn how long your delay is and anticipate how to use it to your advantage.

Taking photos and video of fast-moving

subjects is difficult with a camera phone, but it can be done. Here's some advice to help you get around your camera phone's limitations and capture strong action shots.

Follow the play Whether you're at a professional sports event or a Little League game, it's unlikely you'll be close enough to the action to photograph individual players well. Professional sports photographers use huge lenses to zoom in very close. Obviously, such lenses aren't available for camera phones. So instead of concentrating

on individual players, try to capture the group dynamic. Make sure you know enough about the game so you can anticipate plays and include the relevant parties and gear in your shot. Anticipating the action can also help compensate for shutter lag — press the shutter release just before the most dynamic moment of the play. If you're using autofocus rather than a fixed- or infinity-focus mode, try prefocusing on the area where you expect most action to take place so you can capture it as it happens. Do this by pressing the shutter release halfway and holding it. For another interesting photo, use your phone's panorama mode (if available) to capture a play in three shots that will be automatically stitched together. When shooting video, try following the action by moving the camera phone to keep a key player in the same spot on the LCD.

Don't unintentionally crop legs and arms It's usually better to go one way or the other when photographing people engaged in a sport: Either capture the person's entire body or shoot a closeup of the part of the body that's particularly active or expressive. If you do chop off feet or an arm, do it intentionally, not because you didn't notice they were out of the frame. Also, try to capture people from an angle where you can see their limbs extending when they move. If someone is reaching out to catch a ball, you'll probably get a more dynamic shot if you capture the full length of the arm from the side than if you point your camera straight at the fingertips, looking down the arm.

Use a telephoto attachment You can get a little closer to the action with a tele-photo-lens attachment. The optical quality of accessory lenses varies, but you might be willing to sacrifice some image quality in order to have a closer shot. See if your local shop will let you experiment with a lens before buying.

Pan This technique—difficult even with a fast, digital SLR— is tricky with a slower-shooting camera phone. But if you master it, you can create some very cool images. The goal of panning is to keep a moving subject sharp against a motion-blurred background. To do this, hold the camera phone in both hands —for steadiness—and frame the approaching subject on the LCD. As the subject gets close to you, swivel your body at the waist, keeping the subject framed on the LCD as it moves. Just as the subject moves past you—or a moment before, depending on the shutter lag of your camera phone— push the shutter-release button. Don't stop moving. Keep following your subject with the LCD until the shot is being saved, to make sure you don't stop the camera too soon. If you're using autofocus, prefocus before you start panning. Choose the spot where you expect the subject to be when you release the shutter, then press the shutter-release button halfway and hold it there until you press it fully to take the shot.

Avoid clutter Because camera phones tend to have a large depth of field, background elements won't be blurred out as they usually are in professional sports photographs. If there's a crowd on the opposite side of the court or field, the people in it might come out more clearly than you'd like, cluttering shots of players. Reduce background details (and distractions) by photographing players when there's a lot of distance between them and anything or anyone behind them.

Check out all the angles If you can, roam around the sports venue a little for different perspectives on the game. Shooting from the ground will give you a totally different kind of photo than shooting from the stands. Getting close to the benches or behind the goal can give you great player shots.

Don't neglect the spectators You rarely see people in public showing their emotions more than at a sporting event. They yell, wear funny outfits, engage in unusual physical displays, and occasionally fight or run around naked. So keep one eye on the crowd while you're taking pictures. You might convey more about the tension and excitement of the game in a picture of a fan than of a player. And you're likely to be closer to the spectators as well, making it easier to get good shots of them than of the team.

Turn your camera phone into a helmet cam Helmet cams are usually used by the extreme-sports crowd, and they're exactly what they sound like: protective helmets with little video cameras attached. If you want footage from your perspective while executing a 360 flipwhip, what you need is a camera strapped on your head, and that camera can be your camera phone. There are too many different camera-phone designs to list instructions for attaching a phone to a helmet. Suffice it to say it will involve duct tape or Velcro and a cell-phone holster or dashboard mount that can hold the phone securely without blocking the lens. Improvise.

Use a remote camera phone During a game, sports photographers sometimes use remotely controlled cameras to get close to the action and shoot from unusual angles. You can do the same thing with a camera phone by controlling it remotely. You'll need to install remote-control software on the phone you'll shoot with and then install accompanying software on another phone, a laptop or a PDA, depending on your software. After some practice with your remote-control system, you can place the camera phone wherever you want and connect the two devices wirelessly. You'll see the remote camera phone's screen on the controlling device and can capture an image when the action comes into view.

It can be tricky to capture good images

with your camera phone when you're out at night. Fortunately, there are plenty of tools that improve your chances. There are also cool things a camera phone can do at night that other cameras can't handle.

Reduce visual noise One of the biggest problems with camera-phone photographs taken in even moderately low light is noise (specks that make your images look grainy.) To reduce noise, process your photographs with noise-reduction software on a compatible camera phone or on a computer. Or try converting very noisy images to black-and-white; they often look better that way.

Photograph neon lights at twilight Neon and colored lights photograph best in the evening or early morning with a camera phone. But if you really want to capture some neon color in complete darkness, bump the exposure as far down as you can to expose the lights correctly. Including a bright area like a storefront in the photo will further decrease the exposure. Afterward, use your camera phone's editing software or a computer image editor to increase the photo's overall brightness.

Adjust your exposure for stage lighting You'll need to choose the most important part of the scene and adjust your exposure for it. A spot meter, exposure compensation and sometimes a backlight mode are useful. If you're trying to capture someone lit by a spotlight, make sure night mode is turned off.

Pick the right scene mode Sometimes night mode isn't the best choice for photographing nightlife — it tends to slow shutter speed and increase motion blur. A sports mode will increase the shutter speed to freeze action under bright lights.

Opt for video in rapidly changing lighting You're more likely to capture at least some of the action.

Carry a keychain light If your camera phone doesn't have a built-in light or you want to add a little power to it, carry a small camera-phone light.

BUILDINGS AND INTERIORS

If you take lots of pictures of buildings and interior spaces,

these techniques and tools will help you handle tricky lighting situations despite your camera phone's limitations.

Avoid frontal shots with straight lines Many camera phone lenses suffer from barrel distortion (straight lines appear to bow), especially when you get close to your subject. Avoid taking dead-on photographs of building facades. Try to keep straight lines away from the edges of the frame, where the distortion will be greatest and most obvious. If you shoot from the ground up, buildings will probably appear to narrow near the top in your photograph. Unless you want this effect, photographing building corners and avoiding dead-on shots of façades make perspective distortions less noticeable.

Use distortion-correction software Another way to deal with barrel distortion is to simply correct it. If you have distortion- correction computer software, keep it in mind while shooting. Leave more space around the site you're photographing than you want in the final image, since you'll probably crop the image a bit when you correct distortion.

Use a wide-angle attachment If you can't fit a room or a building in a single shot, try a wide-angle attachment. As with the telephoto attachments mentioned in the Sports section, the optical quality of these accessory lenses varies; but losing a little image quality might be worth it to fit more in the photo.

Use brighter-than-normal room lighting Photographing a room requires lots of light. Use all the lamps and overhead lights available and reposition lamps to fill dark corners. A camera phone flash or light won't be enough to illuminate the whole space. A handheld slave flash is a better option. Try bouncing the flash off the ceiling to create natural, even light. If you shoot interiors often — maybe real-estate shots — consider picking up a few socket-mounted flashes. Shaped like incandescent bulbs, they screw into any standard socket and will be totally inconspicuous in your photo.

Use a double-exposure for windows and interior If you want a well-exposed

photograph of a room with some detail in the windows instead of blank rectangles, use the same double-exposure approach described in the section on landscapes. Take one photograph with the exposure bumped up or with a handheld flash unit so the interior is properly exposed. Then bump the exposure way down so the windows are properly exposed. You'll need to frame the image exactly the same way for both shots, so a tripod is advisable. Download the two images to your computer and use a software program to combine the photos, either automatically or manually. To avoid photos with blank spots where the windows should be, you can also close the drapes or photograph the room at night, when windows reflect the interior.

Assemble an image To fit an entire large building into one print, capture it in several shots and then use stitching software to create one photograph. This can also increase the resolution of the final photograph. Make sure you photograph the building from the same perspective in every shot you'll include in the composite.

Get rid of flickering screens Cathode-ray-tube (CRT) computer monitors and televisions often show a partial or horizontally striped image in camera-phone photos and a flickering image in videos. If you want to include a screen with an image on it in a shot of a work or entertainment environment, make it an LCD or plasma screen.

Use a landscape mode A landscape-scene mode can be a good choice even for shooting buildings and interiors. It usually improves color saturation and contrast; and in more advanced camera phones, it may increase depth of field so more detail is visible in your photo.

Create a virtual tour You can create a virtual tour when photographing the interior of a building for display online. You'll need virtual-tour-creation software to do so; and when you're shooting, take consecutive shots of all areas you want seamlessly connected in the tour. Also take close-ups of particular areas to highlight. The software package will have detailed instructions on how best to photograph the area for optimal tour creation.

Include a reference for scale If you're photographing an extremely large or unusually small building, include a commonly known object to give it perspective (a person always works). If you want to make a low-ceilinged interior look spacious, have any people in the shots sit down. To make a room look more expansive, make sure no furniture or other objects are very close to the camera phone. Objects in the foreground tend to look larger and might make the room look smaller as a result.

PRODUCTS, STILL LIFE, AND DOCUMENTS

MAKE BETTER PICTURES FOR THE WEB: Interesting angles and lighting are two key components of great still-life photography. Clark placed this plate of berry pie near a sunny window and stood on a chair to get directly over it to make this symmetrical photograph.

You can photograph products to sell online, still-life subjects and documents with a camera phone; but you'll need to light your subject carefully and use a few extra tools to get good results. Fortunately, most of the tools you'll need are inexpensive and easy to find.

Create a seamless background If you're shooting a table-top object, create a professional-looking background by putting a large piece of thick paper underneath and behind it, along the wall, with a soft curve where wall meets table. Light it as described later. For larger objects, use backdrop paper from a photographic- or art-supply store. Tape the backdrop to a wall, drape it onto the floor and place your subject on top.

Choose the right background material Paper is cheap, colorful and readily available. Construction paper, thin posterboard and heavy, inkjet papers all curve and don't wrinkle easily. Black velvet is one of the most light-absorbing materials around. White paper diffuses harsh light and works well outdoors in bright sun.

Use natural, lamp or bounced light instead of flash Use natural light or bounced light whenever possible, avoiding direct sunlight. Indoors, use table lamps rather than a flash. For even, diffuse lighting, set up a large piece of white posterboard on each side of the object (and perhaps one above it); then aim a gooseneck lamp at the card so light bounces off of it and onto the object.

Control the angle of the light For even illumination, make sure the light you're using is larger than the object you're photographing. Start in the dark and begin lighting with just one lamp. To reduce shadows, add a second light on the other side of the object and adjust it until you get what you want. A translucent background fabric lit from below will eliminate most background shadows; and a light-color background will disappear when you shine a bright light on it. When you're satisfied with the lighting, check your LCD. You may need to bump the exposure compensation up or down if you use a very bright or dark background.

Use a light tent Essentially a box with sides of translucent, white fabric and a hole to shoot through, a light tent creates a clean, shadow-free background and even lighting. Buy one from a local camera store or online; or make your own (more on that in the accessories section). The object you're photographing goes inside the tent; the lights shine in from outside the tent's fabric walls. Gooseneck or table lamps can light the tent from both sides and from the top.

Use a magnifier For closeups, hold a magnifying glass in front of the lens and cover the whole image area.

Use an LCD loupe When photographing text or a small object, use a loupe for the clearest view of the image on your camera phone's screen. A loupe will magnify the LCD image and help if you have imperfect vision.

Shoot documents dead-on To keep the text in focus when shooting, hold the camera lens parallel to the document surface. Make sure the lighting is even and use the self-timer or a tripod to reduce camera shake.

OUT IN THE ELEMENTS

When you bring your camera phone out in the weather, you'll need to take some precautions and maybe bring along a few accessories. But rain, wind and snow shouldn't stop you from getting good shots. You can even take your camera phone underwater.

Use a waterproof case If you want to take your camera phone snorkeling, buy a waterproof case that allows you access to basic controls. Just don't dive too deep, since the cases won't stand up to a lot of water pressure. A waterproof case can also protect your camera from rain, dusty environments and from salt if you're out at sea. Use a wrist strap or lanyard when in the water.

Prevent backscatter Underwater, a camera flash strikes particles in the water and reflects directly back into the lens, creating bright spots that will mar your prints. Turn the flash off before you jump in. Use a waterproof slave flash if you need illumination and hold it far enough from the camera phone that any reflected light doesn't shine into the lens.

THROUGH RAIN, SLEET OR SNOW: Don't be afraid to try different settings such as "cloudy" or "snowy" in your phone menu to find a better exposure when you are outdoors.

Protect your microphone from wind If you're shooting video, wind can be a problem. Even when you can't hear it, your microphone can. Shield the microphone with your hand to prevent wind from obscuring your audio.

Control shadows in snow Sunlight on a snowy day can create harsh shadows.

Either photograph people standing in shade or use your camera phone's flash to eliminate shadows on your subjects' faces.

Adjust exposure for snow and beaches A snow-covered environment or an expanse of beach can throw off your camera phone's exposure and leave your subject too dark. It can also make snow or white sand come out looking gray. Some phones have a snow or beach mode for this; but if yours doesn't, use exposure compensation to adjust the brightness of your image. To make snow come out white, you'll probably need to bump your exposure up.

Come in from the cold with a Ziploc Camera-phone lenses are well sealed; but if you're in very cold weather, take a Ziploc bag with you and seal the phone inside it before returning to a warm environment. Any condensation will be outside the bag, not inside the camera. Wait until the camera phone warms up before taking it out.

Use an LCD hood In bright sunlight, an LCD hood can help you see the image on your camera-phone screen clearly. You can buy one or make a simple one yourself with cardboard, tape and a rubber band to secure it to the phone. It can be either a box with two open ends that will shade the screen from side lighting or closed on top with an eyepiece to look into. Look for the type that has a strap you can wrap around the phone and tighten so you don't have to hold it in place.

Keep your camera phone comfortable Camera phones do best at moderate temperatures. Cold can decrease a phone's battery life, while heat can produce noise on the sensor that will make your images look grainy or snowy. In the cold, put the phone in a pocket so body heat keeps it warm. In extreme heat, try to keep your camera phone in the shade.

Bring along some filters In snow, water or harsh sunlight, a polarizer will cut glare, allow you to take images that show what's beneath the surface of water, and increase contrast and color saturation. An orange filter restores color balance underwater, but a standard size won't fit on a camera phone. Instead, buy a CC30R gel that's the same color as an underwater filter, cut a little piece of it, and tape the piece over the lens before putting the camera in its underwater case.

Carry a mobile charger Taking pictures and video can drain a camera phone's battery quickly, even more so out in the cold. Even on a one-day excursion, bring a solar charger or a car charger. In a pinch, you can use a crank charger as well.

WILLIAMSBURG, BROOKLYN

Williamsburg, Brooklyn, has long been a place for people seeking both safe haven and wide open space. Centuries ago, Dutch and English settlers created farms. German industrialists built shipyards along the deep drafts of the shoreline. Developers and engineers paced the land, envisioning townships and industrial centers. But it wasn't until the Williamsburg Bridge opened in 1903 that Williamsburg—now part of the borough of Brooklyn, city of New York—became a place of vibrant relief. First came the immigrant populations escaping the cramped and sweltering flats of Manhattan's Lower East Side. They were soon followed by the wounded Europeans who had lost homes and families in World War II. Even now, Williamsburg's brick buildings and tree-lined streets remain home to a large community of Hasidic Jews.

Half a century later, the area now also houses a thriving artistic settlement. Musicians, photographers and painters driven from SoHo by skyrocketing rents have found respite and affordable space in Williamsburg's industrial buildings, abandoned during the economic recession of the 1970s. Photographer Robert Clark calls Williamsburg home. During one week in 2006, he set out to capture the lifeblood of his neighborhood. In these next few pages, he will show you a place redolent with history and ripe with possibility, a place ever connected to Manhattan via elevated subway and Williamsburg Bridge. Like an avuncular guardian, that subway carries Williamsburg's residents on their daily commutes. And that bridge continues to sparkle at night.

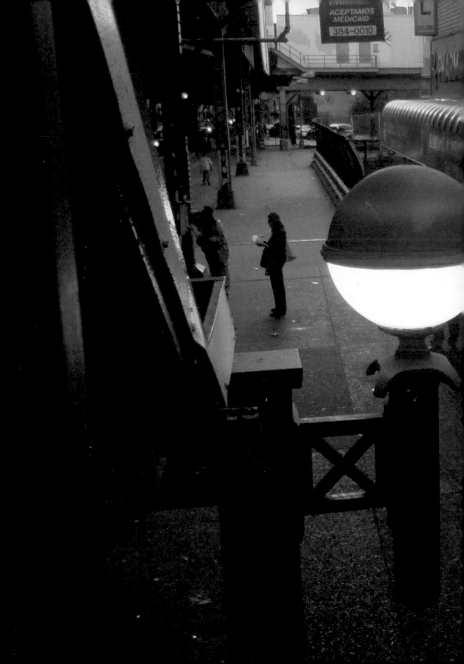

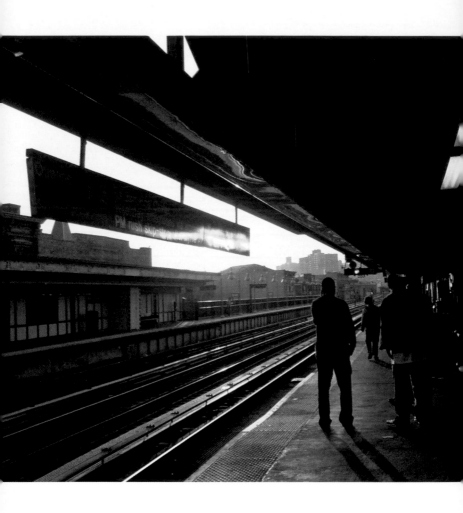

CAUTION - HOT

ROBERT CLARK is a freelance photographer based in Brooklyn, New York. In 2005 he published the first photo book, entitled Image America, using only a camera phone. He has been a frequent contributor to the NATIONAL GEOGRAPHIC MAGAZINE, including an award-winning series of images for a story about Charles Darwin.

Combining photography, videography and mobile-communication into one little device is the trick that sets camera phones apart from other cameras. You can send photos taken with a camera phone directly to a wide variety of destinations—to other phones, printers, Web sites and even postal boxes. With the right tools, you can use your camera phone to track the locations of your shots or decipher messages and links encoded in images. There are also many tools available to help improve the quality of the images you've shot, or to combine them in creative ways. Of course, the capabilities of camera-phone models vary, so check yours for compatibility with other devices, software and services before you spend time and money on them.

SENDING IMAGES

Here are six ways to send images directly to another phone: 1) Send an image to a phone in any location via MMS. This is one of the easiest methods to use. **2)** Send an image wirelessly via Bluetooth to another phone in your vicinity that has a Bluetooth connection. **3)** Send the image wirelessly via IrDA to another phone nearby that has an IrDA port. **4)** Send an image to another phone in any location via e-mail. **5)** Remove the memory card from your phone and put it in a compatible memory slot on another phone, then move the images from the card into the other phone's internal memory. **6)** Connect your phone and another phone to a USB bridge and transfer the images. You can read more about USB bridges in the section on portable storage devices. Check the "What You Need" chart on page 118 for more information on the requirements for using these means of transmission.

Mobile social networks Joining a mobile social network can give you the ability to detect other members in your vicinity and send messages and images to their phones. Each network works slightly differently; but the general idea is that after joining, you download software to your phone and use it to locate and contact other members. Some even offer mobile classified advertising and games you can play with other members who are nearby.

To join a network, sign up online and install software on your phone. Here are some mobile social networks to check out. **1)** www.facebook.com **2)** www.fotochatter.com **3)** www.dodgeball.com **4)** www.funkysexycool.com **5)** www.smallplanet.net **6)** www.juicecaster.com.

The Socialight mobile social network (www.socialight.com) lets you leave and pick up location-specific phone messages called Sticky Shadows. When you're somewhere interesting, use their software to create a Sticky Shadow on your phone. Include a photo, video, text or an audio clip. The software will attach the location to your message, which you then make available to your personal network or a public network.

You can also leave a message or image for other camera phone users in the form of a 2-D bar code. Read more about that in Chapter 4.

COMPUTERS AND PDAS

There are plenty of reasons to transfer your images to a computer: storage, editing with software, and printing or arranging them in an online gallery if you have an Internet connection. Sometimes you might want to send your images to a handheld PDA, either to

share them with someone else who owns the device or to store them when you're away from a computer and need to empty your phone's memory and take more pictures.

You have two things to consider when transferring images from a camera phone to a computer or PDA: how to make a connection between the two devices, and how to manage the transfer of images and other data.

Making a connection Here are six ways to send photos and videos to a computer or PDA from a camera phone. Few camera phones support all of them, but all models support at least one. **1)** Send your images via MMS or e-mail from a camera phone with a data-service plan to an e-mail account that's accessible on the computer. **2)** Remove the memory card from the phone (assuming it has one), put it in its adapter and put the adapter into the corresponding memory-card slot on a computer or PDA or into a card reader connected to a computer via USB. When the card appears in your file browser, copy its contents to the folder where you want to store them. **3)** Send the image wirelessly via Bluetooth to a computer with either an internal Bluetooth receiver or a Bluetooth-to-USB adapter plugged in. You should be able to select the folder to which your images will be transferred with your computer's Bluetooth-management tools. **4)** Send the image wirelessly via IrDA to a PDA with a built-in IrDA receiver or to a computer with an IrDA-to-USB adapter plugged in. You should be able to select the folder to which your images will be transferred with your PDA's system-management tools or with the software that came with your computer's IrDA adapter. **5)** Connect your camera phone to a USB port on your computer with the proprietary USB cable that came with the phone. Some phones have USB mini-B ports instead of a model-specific data port. You can use a standard mini-B-to-A USB cable with them. The phone should appear in your file browser, where you can copy its contents to a folder on your computer. **6)** Send the image wirelessly via WiFi to a computer with an open WiFi connection. You'll need to be connected to an available network to transfer via WiFi.

Once you've figured out which of these types of connection will work with your devices, you've done all you really have to. You can drag, send or beam your images over, confirm they've shown up on the other end and call it a day. However, if you're willing to spend a little more time (and possibly money) setting up an image-transfer system, you'll probably end up with one that will make things work more smoothly and efficiently in the long run. You may also get a lot of useful tools for managing, displaying and sharing images that you wouldn't have if you stuck with the raw essentials. So if you're game to explore some transfer-management options, read on.

MANAGING THE MEDIA TRANSFER

Basic transfer and synchronization software The companies listed here make software that transfers or automatically synchronizes images and other types of data between your camera phone and your computer. To use this type of software, you connect the two devices via USB cable, Bluetooth or IrDA. Some of these companies also sell USB cables compatible with a large number of camera-phone models. The features each software program offers vary depending on the phone model you're using, so check the software maker's information on which tools the software provides with your model.

Some camera phones come with synchronization software provided by the phone manufacturer, so look in the box and see what you have already before you start shopping. There are also USB memory-card readers that come with software for transferring and managing files from your camera phone's memory card and sometimes its SIM card as well.

Futuredial
www.futuredial.com

MobTime
www.mobtime.com

Mobile Action
http://global.mobileaction.com

Susteen
www.susteen.com

Media-management suites The options listed here combine software and services to synchronize images and other data on an Internet-connected computer, the Web and Web-enabled mobile devices such as camera phones (they usually have to be smartphones). Generally, you install software on your computer, phone and any other compatible devices, then drag and drop the media you want on all your devices into a specified area in the software interface. When you take new pictures or create other files, they will be moved into the software's management system and automatically made available on your computer, a Web site where you are given an account, and your camera phone. They all offer extensive features for synchronizing and organizing your media, playing and displaying it and sharing it with others.

Avvenu
www.avvenu.com

TransMedia Glide
www.glidedigital.com

Phling
www.phling.com

Yahoo! Go
http://go.connect.yahoo.com

PRINTERS

Printing connectivity If you have a desktop printer at home, you always have the option of printing your camera phone photos in what is now the old-fashioned way — by downloading your photos to your computer and then sending them to your home printer. But that isn't really in the spirit of mobile imaging, is it?

There are five ways to send photos directly to a home printer, without the intermediary of a computer: **1)** Remove the memory card from the phone, put it in its SD, MMC, or Memory Stick adapter, and put the adapter into the corresponding memory card slot on the printer. **2)** Send the image wirelessly via Bluetooth to a printer with either an internal Bluetooth receiver or Bluetooth compatibility and a Bluetooth adapter plugged into the USB port. **3)** Send the image wirelessly via IrDA to a printer with a built-in IrDA receiver. **4)** Connect a Pictbridge-compatible camera phone to the USB port on a Pictbridge-compatible printer with the proprietary USB cable that came with the phone. **5)** Send the image wirelessly via a WiFi connection to a printer with built-in WiFi support or a WiFi adapter. You'll need to be connected to an available network to print via WiFi.

Once you transmit the image to the printer, you'll complete the printing process by following instructions on the screen of either your phone or the printer.

Most printers can accommodate only two or three of these methods, and many camera phones don't have removable memory cards or Pictbridge support. Bluetooth and IrDA support are much more common, although you should check to make sure your phone has them before buying a printer. WiFi support is still relatively uncommon in both camera phones and printers.

There's just one problem with the direct-printing scenario: the lack of archiving. Sending your photos directly to a printer is convenient when you want to make a print quickly, but make sure to save your image files on a computer or another storage device before you clear your phone's memory for another round of photos.

Printer types There are a few types of printers that offer the connectivity you need for direct printing from a camera phone. (Not every model offers every connection type, so check the specs before you buy one):

Desktop printers: Almost always inkjet models, these usually print on paper sizes between 4x6 and 8x10. Although you probably won't want to print camera phone pictures any larger than 4x6, a desktop printer is a good option if you also want to output larger sizes from a digital camera.

All-in-one printers: These inkjet printers incorporate scanners, copiers and sometimes fax machines, and usually print from 4x6 to 8x10.

Portable printers: Extremely compact, these use either dye-sublimation or inkjet technology to print 4x6 and occasionally 5x7 or panoramic 4x8 sizes. Some can be powered by battery. If you're buying a printer just for camera phone photos, a portable printer may be the best option, since most camera phone photos don't look their best when printed at large sizes. Both dye-subs and inkjets will produce good results with camera phone photos, but there are a few pros and cons to consider:

Dye-sub printers use heat to apply layers of primary-color dye and a protective laminate to the paper, and the dye reel and paper pack are sold together in a package. That means there's a fixed cost for each print. You can calculate it by dividing the cost of the package by the number of sheets of paper included.

Inkjet printers apply tiny droplets of ink to the paper surface. They use different amounts of ink for each photo, depending on the printer settings you use and the content of the image (the more white space and light areas, the less ink needed). That makes the cost of each print variable.

Dye-subs use just one type of glossy paper. A few are able to create matte surface effects, but no consumer dye-subs print on true matte paper. Inkjets, on the other hand, can usually accommodate a range of media options, including matte and sometimes fine-art papers.

Dye-sub printers are especially susceptible to problems with dust. If dust gets inside your dye-sub printer, it will end up on your prints in the form of colored specks and squiggles. Look for a dye-sub with a paper-tray design that prevents dust from getting into the device; and if you buy a dye-sub, protect it with a dust cover.

Not all inkjet inks are equal. Some are not water-

PRINTER MANUFACTURERS

Canon (www.canon.com) all-in-ones, desktop inkjets, portable inkjets and dye-subs

Dell (www.dell.com) all-in-ones

Epson (www.epson.com) all-in-ones, desktop inkjets, portable inkjets

HP (www.hp.com) all-in-ones, desktop inkjets, portable inkjets

Hi-Touch Imaging (www.hitouchimaging.com) portable dye-subs

Kodak (www.kodak.com) desktop and portable dye-subs (including camera docks)

Olympus (www.olympus.com) portable dye-subs (including camera docks)

Panasonic (www.panasonic.com) portable dye-subs

Samsung (www.samsung.com) portable dye-subs

Sanyo (www.sanyo.com) portable dye-subs

Sony (www.sony.com) desktop dye-subs, portable dye-subs

resistant, and some are more prone to fading than others. Do a little research before you buy an inkjet printer. Also plan to pay more for the manufacturer's ink cartridges or cartridges from a high-end third-party ink maker. Cheap third-party inks often fade quickly and sometimes clog printer nozzles.

If you want to compare inks and papers, check out Wilhelm Imaging Research at www.wilhelm-research.com. The site provides independent print longevity test results for particular ink/paper combinations, as well as plenty of general information.

TVS AND DIGITAL FRAMES

TVs If you want to show your camera-phone photos and videos to friends in person, displaying them on a TV seems like an obvious choice. Although many future camera phones will probably provide simple ways to output images directly to a TV, there are, unfortunately, few current camera phones that do so. The models that offer this function come with a cable you can use to connect the phone to the AV jacks on your set.

For people who don't own one of the rare camera phones that can connect directly to a TV, the alternative is to use a third device that connects to a television and provides a means of receiving and playing images. These devices can include gaming consoles such as Xbox or PlayStation, DVD and media players, and portable storage devices and disc burners (see the section on those later in this chapter). There are a variety of input options that may be supported by individual devices in these categories. Here are some to look for:

A memory-card-reader slot compatible with your camera phone's memory card (in its adapter, of course).

A Bluetooth receiver.

A USB input port.

WiFi support for wirelessly connecting the device to your home wireless network and a WiFi-enabled camera phone.

Universal Plug and Play (UPnP) support. UPnP is still rare in camera phones, but those that support it can send images and other items to other UPnP devices wirelessly.

There are many variations in the ways these options can be implemented in different devices

and in how your camera phone's communication tools may interact with them. At an electronics store, try a test run of the products you want to use together; or purchase them from a source that has a reasonable return policy in case your setup doesn't work out.

Digital frames Another display option is to send your images to a digital photo frame. These devices are LCDs with attractive frames; the screens usually measure between five and 10 inches diagonally. They display either a static image or a slide show of pictures, and some can play videos as well. Some frames allow you to upload MP3 files so you can set your slide shows to music that plays on integrated speakers. Most digital frames have memory-card slots so you can simply put a removable memory card from a camera phone into its adapter and insert it in the digital frame's card slot to load images for display. Some also have Bluetooth and USB inputs, and a few support WiFi so if you have a wireless network and one of the few camera phones that offer a WiFi connection, you can send your images directly from the phone to the frame wirelessly.

Most digital frames have built-in storage to hold the images you load onto them, but some can connect to an Internet server where images are stored. Ceiva sells frames along with service plans that allow you to send images to a frame from any Internet-connected computer or camera phone. The frame is connected to a phone jack and automatically downloads new images every day from Ceiva's server. To transfer images to the server from a camera phone, send them via MMS or e-mail to an e-mail address provided by Ceiva.

DIGITAL-FRAME SOURCES
Numerous companies make digital frames; these are just a few of them.

Ceiva
www.ceiva.com

Pacific Digital
www.pacificdigital.com

Parrot
www.parrot.biz

Philips
www.philips.com

Smartparts
www.smartpartsproducts.com

Ziga
www.zigausa.com

PORTABLE STORAGE DEVICES AND DISC BURNERS

If you're traveling without a laptop and taking lots of pictures, you may end up with a full camera-phone memory and nowhere to put the photos so you can delete them from the phone and take more. One way to solve this problem is to open an online gallery in advance and use an uploading tool that transfers full-resolution images. Read more about that in the section on sending images to Web galleries, moblogs and social networks. If your camera phone uses removable memory cards, carry a second memory card. Another option is to carry a

compact storage device or disc burner for transferring images to. If you're using both a camera phone and a digital camera on a trip, this might be the best choice.

One of the least expensive, most compact portable storage options is a USB bridge that connects your camera phone to a USB key (a.k.a. a thumb or flash drive) or pocket hard drive. If you already carry an MP3 or portable media player, you may be able to transfer images to it with a USB bridge. This is a small, simple device with two USB type A ports — one for plugging in the device you're transferring files from and another for attaching the receiving device. Both devices must function as USB mass-storage devices. Some bridges also have memory card slots you can use as an alternative to the USB input.

To transfer from your camera phone with a bridge, you'll need a compatible USB cable or a mobile-memory-card reader with a USB connector. If the bridge has an SD, MMC or Memory Stick card slot, you can simply bring the appropriate adapter that came with your mobile memory card. If you're transferring images to a device without a built-in USB connector, such as an MP3 player, bring that device's USB cable as well.

USB key capacities typically run as high as 4GB, which allows you to save a large number of photos and videos, even at high resolution. If you want even more capacity, move up to pocket hard drives, which are slightly larger than USB keys but offer capacities as high as 12GB. Both options are very affordable, with a 4GB USB key about $100 and 12GB pocket drives available for less than $200.

Options that are both pricier and larger (but preferable if you're also shooting with a digital camera or MPEG-format camcorder) include portable hard-drive-based storage devices and disc burners. To use these, you need to store your images on a mobile memory card you can remove from the phone and put into its adapter, which fits in a memory card slot on the storage or burning device.

Hard-drive-based storage devices can be as compact as a portable MP3 player and usually have at least

USB BRIDGE SOURCES:

Aleratec
www.aleratec.com

Delkin
www.delkin.com

Sima
www.simaproducts.com

**POCKET HARD
DRIVE SOURCES:**

Archos
www.archos.com

Iomega
www.iomega.com

LaCie
www.lacie.com

Seagate
www.seagate.com

Samsung
www.samsung.com

Smartdisk
www.smartdisk.com

Verbatim
www.verbatim.com

Western Digital
www.westerndigital.com

**PORTABLE STORAGE
DEVICE SOURCES:**

Epson
www.epson.com

Jobo
www.jobodigital.com

Sima
www.simaproducts.com

Smartdisk
www.smartdisk.com

Wolverine
www.wolverinedata.com

**PORTABLE DISC
BURNER SOURCES:**

Aleratec
www.aleratec.com

Delkin
www.delkin.com

EZPnP
www.ezpnp.com

Jobo
www.jobodigital.com

Mediagear
www.mediagear.com

Smartdisk
www.smartdisk.com

40GB of space for storing files. Prices start around $150 and increase with the capacity and the quality of the device's display. Some have a simple status LCD, while others have large, high-quality screens for viewing images. One of the advantages portable storage devices have over their smaller counterparts is a display that lets you verify that your images have been transferred.

You can also burn your images to a CD or DVD on a portable disc burner with memory card slots. Prices for portable burners start at about $150.

KIOSKS AND
BRICK-AND-MORTAR STORES

If you prefer to pick up prints from a store, send them to one that offers printing services directly from your camera phone. You can also make prints of your camera-phone photos at a store's self-serve kiosk. Here's how these options work:

Sending photos to a store The mobile software and service you need to place an order from your camera phone are provided by companies such as Fujifilm, Pixology and Pictavision and are available through mobile-phone-service providers. Check with your carrier to see if a printing service is available on your phone. To use an available service, you need a wireless Internet plan and a compatible phone. In the main menu for Internet options on your phone, navigate to the image applications and services link, then select the service you want to use from the list of options. Follow the instructions for using the software provided to upload your photos, enter information that identifies the area where you'd like to pick them up—such as a zip code—and select a nearby store from the list provided. You can pay with a credit card right on the phone. After the photos are uploaded and received, the store where you're picking them up will send you a confirmation e-mail telling you when your prints will be available.

Using a self-serve kiosk All self-serve printing kiosks have full-size memory-card slots for uploading image files. If your camera phone saves images on a removable memory card, take it out, put it in its adapter and insert it into the memory-card slot on the kiosk. You'll have to remember to carry its adapter with you to make prints this way. Some kiosks also support wireless transfers via IrDA or Bluetooth. If you're using IrDA, simply select the image you want to print, choose the option to send via IrDA from your phone's menu and point the phone at the kiosk. For Bluetooth transfers, you'll probably have to go into your phone's communication menu and detect the kiosk before sending images. Once your photos have been transferred to the kiosk, you can make some basic adjustments such as cropping or rotating images. Then you just wait for the kiosk to produce the prints.

PRINTING YOUR PICTURES: Gone are the days when you had to drop a film canister off at the local shop; but now you can have total control over cropping, color, and the number of prints you want.

WEB GALLERIES, MOBLOGS AND SOCIAL NETWORKS

All Web galleries, moblog hosts and social networks offer tools for uploading photos and sometimes videos from a computer. (Read more about these types of Web sites and the features they offer in Chapter 4.) Many of the sites also allow you to upload images from a camera phone. They usually provide an e-mail address for you to send images to via MMS or with mobile e-mail software. You give the site your mobile-phone number or a special password for the subject line of the message when you send an image from your camera phone; then the site can associate the image with your account. When you send in images, the site automatically adds them to your album, moblog or personal Web page.

There are also services and software that provide more efficient and sometimes less costly ways to get your images onto the Web. Some allow you to send full-resolution images instead of the smaller files MMS can handle. Some of these tools can be used to send images to many different gallery, blog and social-networking Web sites. You should be able to find a list of the sites supported on the Web site of the company providing the tools. Other tools are designed exclusively for posting images on a particular site. Most of the software described here is available for free.

Blogplanet — www.blogplanet.net — Mobile-blogging software that includes writing tools and an integrated camera-control interface that lets you take a picture and send it directly to your moblog. Compatible with many blog-hosting sites and platforms.

Nokia Lifeblog — www.nokia.com/lifeblog — Software for compatible Nokia camera phones that organizes images on a timeline on the phone, transfers them to a computer via a Bluetooth or USB connection and adds them to a timeline-based album display on your computer. Can also upload images and text from a camera phone to a TypePad moblog.

Picoblogger — www.picoblogger.com — Mobile software that provides a "community dashboard" for viewing and posting comments to moblogs, as well as tools for writing your own moblog entries and attaching images to them. Uploads to the Picostation moblog site and many other blog hosts. Also provides mobile video-download tools.

Pictavision — www.pictavision.com — Mobile software that lets you view albums on many Web gallery sites and automatically uploads camera-phone images to Web galleries and moblogs. Also includes an integrated camera-control interface and lets you add voice messages and text to photos. Available in several languages.

ShoZu Share-It — www.shozu.com — Mobile software that uploads full-resolution photos and videos to a wide range of Web gallery, blog-hosting and social-networking sites. Uploads selected images in the background while you use other phone functions. Lets you attach text to images, as well as tags for use on sites that allow you to organize and search images by tags. Automatically resumes interrupted uploads.

Splashdata Splashblog — www.splashdata.com/splashblog — Mobile-blogging software that lets you view, subscribe to and comment on other people's blogs and send text and images to your own moblog from your camera phone. Includes an integrated camera-control interface and can upload full-resolution photos. Compatible with moblogs hosted on the Splashblog site (www.splashblog.com).

Umundo — www.umundo.com — Service that provides an e-mail address to send images to and from a camera phone via MMS, then lets you export those images from a desktop Web-browser-based tool to a variety of Web gallery, social networking and blog host sites.

FAX MACHINES

You can use your camera phone to create a PDF of a document, business card or white board and send it to a fax machine or an e-mail address. All you need is MMS or e-mail service on your camera phone and a free account with a scanning service. One caveat: Some services won't accept images captured with camera phones that don't have at least a megapixel of resolution. Use the highest resolution and quality settings when photographing a document for scanning.

Here's how the process works:

Open an account online with a mobile-document-scanning service such as Scanr (www.scanr.com) or Qipit (www.qipit.com).

Photograph a document and send it via MMS or e-mail to an e-mail address provided by the scanning service. In the subject line or body of the message, enter the fax number or e-mail address where you want the document sent. Any additional text you type in the message will appear in the fax header or recipient's e-mail message.

The scanning service receives the message, opens the image attached, optimizes the image contrast and brightness to make the text clear and converts the image file into a searchable PDF.

The scanning service sends the PDF to the fax number or e-mail address you

entered in the MMS or e-mail message. The scanning service will also send a copy to your e-mail address and save the document in your online account.

(You can log into the account from a computer at a later time and send saved documents to fax numbers and e-mail accounts or download the PDFs.)

If you have a compatible phone and are using a scanning service that offers this feature, you can create a multipage PDF by attaching several photos to a single MMS or e-mail message. The scanning service will put them all in one multipage PDF file. Although most often you'll want to send black-and-white documents, creating a color PDF is an option sometimes available.

POSTAL BOXES

Sending photos by MMS and e-mail is handy, but sometimes a paper postcard just feels more personal and thoughtful. Maybe you even know people who receive only snail mail. You can send a photo and a message from your camera phone to a postal mailbox using a mobile-postcard service.

The software needed to do this is usually available through mobile-phone-service providers. (Not all service providers offer mobile-postcard software, and it's not supported by all phones.) You wirelessly download the software to the phone from a pre-installed service such as Verizon's Get It Now or Cingular's MEdia Mall; and it guides you through the process of creating and sending a postcard. Fujifilm, Kodak and Shutterfly all offer mobile-postcard services through phone-service providers.

To create and send a postcard, open the software and select a card design. Some services let you choose from an assortment of illustrated frames. Next, select the photograph you want to use, type a message to go on the blank side of the card, enter the recipient's name and address, and hit send. The cost of the postcard — usually about $2 — will be charged to your mobile-phone account.

A couple of British services also allow you to create postcards by sending them a photo, text and the recipient's name and address via MMS:

Mobycards **PhotoBox**
www.mobycards.com www.photobox.co.uk

Check their Web sites for prices and to find out whether they will mail a postcard to the country where your recipient lives. Remember that you may pay roaming charges for the MMS transmissions, depending on your data-service plan and location.

YOUR ARCHIVE

A lot of camera-phone photos and videos aren't worth saving. But one day you might wish you had actually held onto the image files for a particular special occasion. To make sure you do, decide on a place to archive your camera-phone images and make it a habit to deposit them there every time you clean out your phone's memory. Delete any images you know you don't want to save right away to avoid clutter and wasted drive space.

There are a few good archiving options:

Online An online gallery or moblog that you regularly upload images to can be a convenient archiving option. Just make sure the service you're using won't delete images after a period of time and use an uploading method that allows you to send full-resolution images to the site. Also make sure you can download the full-resolution files from the site or have them sent to you on a disc.

On disc Another option is to use a portable disc burner to archive your images on CDs or DVDs directly from a camera phone's memory card. You could also purchase a portable storage device and use it as a dedicated camera-phone image archive. Make sure you can transfer your images easily to the device you choose; you'll probably need a camera phone with a removable memory card to do it.

On your computer Most people simply store their image files on their computer, a fine option as long as you make sure to back up its contents periodically. If you want to do the utmost to preserve the quality of your photographs, convert the JPEG files you download from the camera phone into TIFF files. JPEG files lose a little bit of data every time you open them, edit and resave them. Over time, that can lead to image degradation.

Keeping track of all the images you download to your computer can be difficult if you don't start out with an organized system. It's best to designate a folder or series of folders for your archive instead of just dumping the files into your system. It's also a good idea to rename each batch of images with a meaningful word or phrase as soon as you download it. That will make it easier to organize and search your images in the future.

Fortunately, there are a lot of software tools available to help you manage your image files. You can use synchronization programs such as the ones described in the section on sending your images to a computer. Most image-editing programs also include file-management tools that can organize and search for images by criteria such as dates. If you don't already have software that provides you with the preferred tools,

purchase a separate image-management program. Here are a few desktop image-file-management programs that range in cost from free to inexpensive:

Corel Snapfire
www.snapfire.com

Google Picasa
http://picasa.google.com

Ulead Photo Explorer
www.ulead.com

POINTS ON A MAP

If you'd like to keep track of where your camera-phone photos were taken, use geocoding, a process that attaches location information to an image file. Once your images are geocoded, you can link them to an online map marked with links to the photos. Clicking on the photos takes viewers to a location on the map. There are numerous Web gallery sites and social networks that provide maps to which you can link geocoded photos.

Two things must be done in order to geocode a photograph: First, you have to capture information about the location where you took the photograph; second, you have to attach that information to the photograph. There are various approaches to accomplishing these tasks, each with advantages and disadvantages:

Acquiring location information There are two main sources of location information for geocoding: 1) **GPS receivers.** GPS information is precise, since it describes the exact location— by latitude and longitude— of the GPS receiver you're presumably holding. However, GPS devices don't work indoors, and there are some outdoor areas where you might experience poor reception. There are also relatively few camera phones with built-in GPS receivers, so you likely will need a separate GPS device. 1) **Cell towers.** Getting location information from a cell tower simply tells you where the nearest tower is. It doesn't provide a description of your exact location. It can be acquired by any phone, wherever you have service. That means it will often be available indoors, although it may not be available in the great outdoors.

Attaching location information The easiest way to attach location information to a photo is using mobile software that automatically tags photos with your location as soon as you take them, then uploads them to a Web site that links geocoded photos to a map. If the software uses cell-tower information, you can use it on phones that don't have built-in GPS as long as they're compatible with the software itself. If the software requires GPS information and you don't have GPS, you'll need a separate GPS unit that can transfer its GPX data files to your phone via Bluetooth. You'll also have to

make sure the software is capable of finding and using the data files that are transferred.

When you're using a camera phone that doesn't have built-in GPS and can't communicate with a separate GPS receiver or run software that uses cell-tower information, you can geocode your photos on a computer. You'll need desktop software that can link the images and GPX data tracks that you transfer to your computer.

One very important thing to remember if you're linking photos from your camera phone with GPS data acquired by a separate receiver is that the date and time on the two devices must be synchronized.

Software Web sites such as www.geosnapper.com, www.plazes.com, and http://triptracker.net offer their own geocoding software. Here are some other software options for geocoding photos on your camera phone or your computer:

GeoSpatial Experts — www.geospatialexperts.com — GPS-Photo Link desktop software that links photos to GPX data.

Merkitys-Meaning — http://meaning.3xi.org — Camera phone software that links photos to GPX data from a Bluetooth-connected GPS receiver.

OziPhotoTool — www.oziphototool.com — Desktop software. OziExplorer imports GPX data, and OziPhotoTool links it to photos.

RoboGEO — www.robogeo.com — Desktop software that links photos to GPX data.

Sony Image Tracker — Desktop software that links photos to GPX data. Sold with Sony's GPS-CS1 GPS receiver (take a look at it in the accessories section of Chapter 1)

ViewRanger — www.viewranger.com — Camera-phone software that links photos to GPX data from a built-in or Bluetooth-connected GPS receiver. Also displays maps and location information on the phone.

World Wide Media Exchange — http://wwmx.org — WWMX Location Stamper and TrackDownload Desktop software. TrackDownload imports GPX data, and Location Stamper links it to photos.

ZoneTag — http://zonetag.research.yahoo.com — Mobile Software that tags photos with location information from cell towers and uploads them to the Flickr Web site.

FOR YOUR EYES ONLY?: James Bond wannabes now have the power to map their every move with geocoding software and Web sites that can track where you are and when you are there instantly.

WHAT YOU NEED

There are numerous means of sending images from a camera phone to the many destinations that can receive them. This chart provides an overview of these means and tells what you need to have on the phone and on the other end to use each means of transferring images. You can use the chart simply to figure out what your phone is capable of, or you can look it over to decide which communication technology you'd like to have in a new phone.

MEANS OF TRANSMISSION	NEEDED ON THE CAMERA PHONE
Memory card	Memory card slot and compatible removable memory card
USB	Standard USB mini B port and standard USB mini B to USB A cable OR Data port (the one where you plug in the charger) and compatible USB cable
Bluetooth	Built-in wireless Bluetooth transmitter and mobile service provider that enables full Bluetooth functionality (check with your carrier)
E-mail	Data service plan and e-mail client software
MMS Multimedia Messaging Service	MMS service plan
IrDA Infrared Data Association	Built-in IrDA port
WiFi 802.11a/b/g/n	Built-in wireless WiFi connectivity and available WiFi connection
Postal service	MMS service plan OR data service plan and e-mail client software AND mobile postcard service
AV connection Audiovisual connection	AV-out port and compatible cable
Fax	Fax software and data service plan
UPnP Universal Plug and Play	Built-in wireless UPnP connectivity
Data network	Data service plan and mobile uploading software and service

The more advanced your camera phone is, the more options it will provide for transferring images. Having a data service plan that offers high-speed data network access will improve your options as well. Before you fall into the habit of using the transfer method you encounter on your phone, try out the available means of transmission to find out what works most quickly and easily, and will cost you the least in service charges.

NEEDED ON THE RECEIVING DEVICE OR SITE	DESTINATIONS THAT MAY BE COMPATIBLE
Built-in or USB-connected mobile memory card reader OR Built-in or USB-connected full-size memory card reader and adapter for mobile memory card	Computer, Digital frame, Kiosk, Other mobile phone, PDA, Portable disc burner, Portable storage device, Printer
USB A port	Computer, Digital frame, Portable disc burner, Portable storage device, Printer
Built-in wireless Bluetooth transmitter or Bluetooth adapter	Computer, Digital frame, Kiosk, Other mobile phone, PDA, Portable disc burner, Portable storage device, Printer
E-mail account, e-mail client software, and Internet connection	Brick-and-mortar store, Computer, Digital frame, Fax machine or e-mail-based fax account, Moblog, Other mobile phone, PDA, Social network, Web gallery
Service plan and phone that can receive MMS OR e-mail account, e-mail client software, and Internet connection	Brick-and-mortar store, Computer, Digital frame, Fax machine or e-mail-based fax account, Moblog, Other mobile phone, Social network, Web gallery
Built-in IrDA port OR IrDA-to-USB adapter and USB port	Computer, Digital frame, Kiosk, Other mobile phone, PDA, Printer
Built-in wireless WiFi connectivity OR connected WiFi adapter AND available WiFi connection	Computer, Other mobile phone, Printer
Postal mailbox	Postal mailbox
AV-in jacks	TV
Fax number and fax machine OR E-mail-based fax service	Computer, Fax machine or e-mail-based fax account, Other mobile phone
Built-in wireless UPnP connectivity	Gaming console, Media player, TV, Computer
Web site support for uploading software and service	Moblog, Social network, Web gallery

All images captured by camera phones are compressed when saved in the phone's memory or on a removable memory card. Uncompressed image files would be too large for the memory to hold many and too large to send from the phone

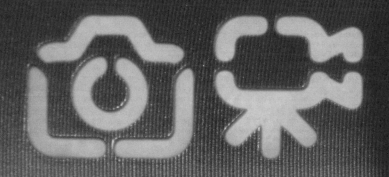

via mobile data network. When your camera phone compresses an image, it uses a compression/decompression algorithm, or "codec." Whenever you open and close the image file, your software employs that same codec.

PHOTO AND VIDEO FORMATS

Photo files Camera phones use JPEG compression when saving photos. The file names of your camera-phone photos will therefore end with ".jpg." This type of compression, also widely used in digital cameras, reduces the size of the image file by discarding redundant visual information and information that can be deduced from other data. When you open the image, the JPEG codec figures out what the discarded information should be and reconstructs it.

JPEG is a lossy format, so if you open, edit and resave JPEG images often, they will lose relevant data over time and their quality will deteriorate. You can save your images as uncompressed TIFF files if you want them to be more stable; and you can also convert JPEGs to other image-file formats if you need to for a special purpose. Most photo-editing software can handle this task.

Video files Video captured by camera phones is most commonly stored in one of the 3GP formats, which are used mainly by camera phones. There are two versions of 3GP: GSM phones use 3GPP, while CDMA phones use 3GPP2. The names of camera-phone videos saved in this format will end with ".3gp" or ".3gp2."

The 3GP formats are container formats. Containers hold other files and allow them to be used by compatible software and devices. 3GP containers hold a video file, usually compressed in the MPEG-4 or H.263 format, along with a corresponding audio file, usually compressed in the AAC or AMR format. The 3GP container allows the video to be transferred over mobile-data networks and played on camera phones and other portable devices.

Not all computer-software programs support 3GP formats. If you want to edit or play your 3GP video on a computer and the program you want to use doesn't support it, you can convert it to another format with a different program. Use editing software that supports the format to do the conversion or use a dedicated conversion program. The video-editing programs listed in the Software Toolbox support 3GP formats. Find a list of programs that play 3GP files and convert them to other formats on the 3GP Organization's Web site (www.3gp.com).

Some camera phones save MPEG-4 video and AAC audio files in an MPEG-4 container. These video files end with ".mp4." This method produces larger files and generally retains higher image quality, but it isn't suited for sending videos to other phones or devices over a mobile data network. If you're going to save your videos for editing on a computer or displaying on a larger screen, MPEG-4 is a good choice. Many computer video-editing programs and video players support MPEG-4 files. Most camera phones that offer MPEG-4 can also save video in the 3GP format for sending on a mobile data network.

SOFTWARE TOOLBOX

All of the software programs listed here are available for less than $100, most for much less, and a few for free. Free trials you can download are available for most of the programs too. Check the software maker's Web site for price information and to make sure your phone is compatible with the software if it's a mobile application.

NAME AND WEB SITE	DESCRIPTION
Photo editing	
Adobe / Photoshop Elements www.adobe.com	Offers a broad range of automatic and manual tools for correcting image flaws and applying effects, including panorama and image-merging functions. Also provides tools for organizing, displaying and sharing photos.
Apple / iPhoto www.apple.com	Part of Apple's iLife suite, which also includes video editing, disc burning, audio editing, and Web-site-creation programs for Mac users. iPhoto provides a strong selection of editing, effects and organization tools.
Arcsoft / Photobase Deluxe www.arcsoft.com	Offers many functions for a mobile-photo editor, with tools for image correction, effects, panorama stitching and file organization.
Bit-side / Camera Magica www.bit-side.com	Provides a good range of image-correction and effects options, as well as panorama-stitching and photomontage tools.
Corel / Paint Shop Pro Photo www.corel.com	Provides a broad range of options for correcting image flaws and applying effects, including manual tools and many automatic functions. Also offers tools for organizing both photo and video files.
Fixer Labs / FixerBundle www.fixerlabs.com	Package of plugins compatible with numerous image-editing programs and includes FocusFixer, ShadowFixer, NoiseFixer and TrueBlur.
Google / Picasa http://picasa.google.com	Primarily an image-file management program, it also provides basic editing functions and simple tools for sending photos to Web sites, blogs, e-mail instant messaging, and other destinations.
Helicon Soft / Helicon Filter www.heliconfilter.com	Provides a useful selection of image-correction tools— including distortion and perspective correction— in a very simple interface. Includes a function for merging identical shots with different exposures.
Magix / Digital Photo Maker www.magix.com	Basic photo editor offering many automatic tools for correcting typical camera-phone-image flaws, as well as image-file organization tools. Facilitates uploading edited images to camera phone.
Microsoft / Digital Image Suite www.microsoft.com	Provides a wide range of image-correction and effects tools, including many automatic options and templates. Facilitates file organization and sending edited photos to camera phone, disc and other destinations.

NAME AND WEB SITE	DESCRIPTION
Nero AG / Nero PhotoShow Deluxe www.nero.com	Offers many automatic and manual correction and effects tools, as well as options for archiving, organizing and sharing images.
Pervasive Works / Photozox www.pervasiveworks.com	Provides a large collection of graphical frames to add to photos, as well as effects and basic image-correction tools.
Power of Software / Photo Pos Pro www.photopos.com	Provides many advanced photo-correction and effects features for a low price. Also includes tutorials and automated tools for novices.
Digital Light & Color / Picture Window Pro www.dl-c.com	An advanced photo editor priced like a basic one. A good choice for serious photographers using a camera phone in addition to other cameras.
Roxio / PhotoSuite www.roxio.com	Provides automatic tools for image correction and effects, as well as many functions for sharing and displaying images, including advanced slide-show-creation tools.
Stoik / Cameraphone Enhancer www.stoik.com	Corrects common camera-phone-photo flaws, especially image noise.
Ulead / PhotoImpact www.ulead.com	Provides numerous automatic tools and tutorials for image correction and effects, as well as some advanced options and photo-merging capabilities.
VicMan / Mobile Photo Enhancer www.vicman.net	Corrects common camera-phone image flaws, including noise, vignetting, exposure problems and color casts. Enhances multiple images at once.
WildPalm / CameraFX Pro www.wildpalm.co.uk	Provides numerous special effects and a few basic image-correction tools.
XRaptor / Photo Professional	Includes a good selection of image-correction tools, as well as effects and options for saving photos in formats appropriate for a range of display types.
Zensis / PhotoRite SP www.zensis.com	Provides automatic image-correction functions and numerous effects.

Video editing

Adobe / Premiere Elements www.adobe.com	Provides a broad range of video-editing and effects tools and supports several camera-phone video formats. A good choice if you also want to edit video from a camcorder.
Apple / Quicktime Pro www.apple.com	A basic video editor that supports camera-phone-video formats. Also provides tools for audio editing and photo slide-show creation.
Arcsoft / Video Impression Mobile Edition www.arcsoft.com	Basic video editor that lets you trim and combine clips, add transitions between segments and create titles and captions.
Ulead / VideoStudio 10 www.ulead.com	Provides a broad range of video-editing and effects tools and supports several camera-phone-video formats. Requires a Ulead plug-in application for some formats. A good choice if you also want to edit video from a camcorder.

Composition guides

Power Retouche / Golden Section
http://powerretouche.com

A plug-in application that you can add to a number of image-editing pro-grams. Displays a good selection of image-composition overlays, including a Rule of Thirds grid, to allow cropping for better composition.

Two Pilots / Composition Pilot
www.colorpilot.com

Displays a selection of image-composition overlays, including a Rule of Thirds grid. Can be used with any program that displays images.

Redeye and greeneye removal

Stoik / Redeye AutoFix
www.stoik.com

Turns red pupils a natural dark gray. Can automatically correct multiple images at once.

Two Pilots / Pet Eye Pilot
www.colorpilot.com

Turns green, blue or yellow pupils in photographs of animals a natural dark gray.

Two Pilots / Red Eye Pilot
www.colorpilot.com

Turns red pupils a natural dark gray.

VicMan / Red Eye Remover
www.vicman.net

Turns red pupils a natural dark gray; pro version processes multiple images at once.

Distortion correction

**Altostorm / Rectilinear Panorama
Home Edition**
www.altostorm.com

A plug-in application that you can add to a number of image-editing pro-grams. Corrects geometric distortions, straightens curved lines and cre-ates curves as a special effect.

Grasshopper / ImageAlign Professional
www.grasshopperonline.com

Provides simple tools for correcting perspective and lens distortions, including curvature and skewing.

Two Pilots / Perspective Pilot
www.colorpilot.com

Corrects perspective distortions by letting you select vertical and hori-zontal lines to realign elements in the photo.

Noise reduction

ABSoft / Neat Image
www.neatimage.com

Reduces noise and compression artifacts, and provides tools for creat-ing a custom noise-reduction profile for your device.

Imagenomic / Noiseware Mobile Edition
www.imagenomic.com

Reduces noise and compression artifacts. Also check out Imagenomic's more advanced desktop software.

Picturecode / Noise Ninja
www.picturecode.com

Reduces noise and compression artifacts, and provides tools for creat-ing a custom noise-reduction profile for your device. Provides advanced manual tools and can automatically process multiple images at once.

NAME AND WEB SITE	DESCRIPTION
Stoik / Noise AutoFix www.stoik.com	Reduces noise and provides tools for creating a custom noise-reduction profile for your device. Also provides sharpening tools.

Panorama and montage stitching, photo merging, and virtual tour creation

360 Degrees of Freedom / 360 Panorama Professional www.360dof.com	Stitches images together to create panoramas, photomontages and virtual tours.
Almalence / PhotoAcute Mobile www.photoacute.com	Lets you create one large photo out of several shots to increase final photo resolution. Works with PhotoAcute Studio desktop program to correct common camera-phone image flaws.
Bit-side / PanoMan http://panoman.net	Guides you through multiple-image alignment and capture, and stitches photos into horizontal or vertical panorama.
iseemedia / Photovista Panorama www.iseephotovista.com	Creates 360-degree panoramas and corrects image flaws.
MultimediaPhoto / Photomatix Pro www.hdrsoft.com	Automatically merges multiple photographs that are identical other than being exposed differently. Also includes high-dynamic-range tools for serious photographers.
PanaVue / ImageAssembler Standard Edition www.panavue.com	Creates 360-degree panoramas and photomontages, and corrects image flaws.
Scalado / PhotoFusion www.scalado.com	Guides you through multiple-image alignment and capture, and stitches photos into horizontal or vertical panorama or a photomontage. Also provides image-correction and effects tools.

Comics and games

Bulbon / Comeks www.comeks.com	Lets you create comic strips out of your photos.
dotPhoto / Pictavision Games www.pictavision.com	Lets you add your photos to camera-phone games.

By now you may have realized that camera-phone photos and videos are no longer relegated to the "fun but useless" category of your digital photo album. In addition to posting images in mobile blogs and Web galleries, people are using camera phones to shoot feature films and music videos, capture breaking news events, flirt with strangers, create art exhibits and participate in multiplayer urban games. Camera phones have even become important in a pastime that's at least as popular as photography: shopping. This chapter will give you the lay of the land and show you which directions you can take to explore it. It also provides resources for keeping up with the latest mobile imaging developments and finding camera phone reviews.

MOBLOGS

In the beginning, there was the Weblog,

or blog. It was a Web site that turned out to be so simple and cheap to create and update that soon there were thousands of blogs. Some are written by professional journalists for audiences of millions; some are written by pajama-wearing amateurs for a handful of readers. **In addition to written blogs, there are photoblogs**, which are composed mainly of photographs, and vlogs, which are mostly videos. All blogs have a few things in common: They follow the same chronological format, with the most recent entry coming first; they allow readers to post comments on entries; and they almost always link to other blogs, forming an interconnected community known as the blogosphere.

Now you have moblogs— short for mobile blogs. What distinguishes a moblog is its ability to be updated and viewed from a portable device equipped with Internet service. That means you can start up a moblog and add pictures, videos, text, and sometimes sound to it from wherever you are with your camera phone.

HOW TO CREATE A MOBLOG
There are a couple of easy ways to create a moblog:

Buy a phone with integrated moblog software Phone vendors such as Sony Ericsson and Nokia have teamed up with moblog services to provide seamless moblogging. Danger hosts moblogs itself for Sidekick and Hiptop users. The blogging software is already installed on the phone, and starting a moblog can be as easy as taking a picture and selecting "blog this" or "post to Web" in an onscreen menu. Instructions on the phone and the Web site where the blog is hosted will guide you through the rest

of the setup procedure. Some of these services are free and some require a paid account with a moblog host. Find out which moblog host your phone vendor is working with and look up the host's pricing to find out what it will cost.

Sign up with a moblog host Internet service providers, social networking sites, Web portals and publications are among the many types of online entities that provide the tools you need to set up your moblog and the server space where it can live, in many cases for free. There are also dedicated blog and moblog hosts. As you would expect, they're a step ahead of most of the crowd in terms of providing advanced features and a smooth moblog experience. They also provide lots of community tools for searching and interacting with other moblogs using the same host. Once you register, the host site will instruct you how to load blogging software onto your phone and how to upload from your phone or a computer. Most dedicated moblog hosts offer a basic moblog for free or for a low price and charge more for added features.

CREATE A MOBLOG: The small size of camera phone files are ideal for digital transmission via e-mail or uploading to a Web site. Check out some of the moblog addresses provided for ideas and tips.

Moblog features There are many tools available for customizing and distributing your moblog. Most blog services offer more advanced features at a higher monthly or annual subscription rate, so shop around and see which provider offers the best deal on the features you want. Here are some important options you can look for:

Advanced templates, editing and design tools You don't have to know how to do more than click a few template selection boxes and fill out an online form to set up your moblog, but if you want to, you can do much more than that. Many blog hosts provide advanced tools for customizing the site design, including HTML and CSS editors.

Permission options for contributors and viewers. Some moblog hosts allow you to make your moblog private so that only approved viewers can see it. Some also let you designate multiple contributors, so that you can set up a group blog.

Syndication and subscriptions. Blogs and moblogs can be syndicated with RSS (Real Simple Syndication) and Atom technology. In other words, with syndication, you can permit headlines and short pieces of text from your moblog to appear in a constantly updated area of another blog or Web site. It's like a news ticker for the Web. You can subscribe to other people's syndicated blogs and moblogs so that their head-

lines appear in a feed on your site, and you can also choose to receive notifications when the blogs you subscribe to are updated.

Audio uploading. If you really hate to type, some hosts will let you update your moblog with audio recordings from the field. You just call your moblog and say what's on your mind, and the host posts the call as an MP3 entry.

Domain forwarding. If you have your own URL, some hosts will redirect your moblog so that it appears at your Web address.

MOBLOG HOSTS
There are many sites that host moblogs. These are some of the most popular and advanced.

Text America — (www.textamerica.com) — Dedicated moblog host with both free and paid hosting.

moblogUK — (http://moblog.co.uk) — Dedicated moblog host with both free and paid hosting.

SnapnPost — (www.snapnpost.com) — Dedicated moblog host with free hosting.

Blogger Mobile — (www.blogger.com/mobile-start.g) — The moblog arm of blog host Blogger, owned by Google. Provides free hosting.

Mobile Earthcam — (http://mobile.earthcam.com) — Dedicated moblog host with both free and paid hosting. Also provides camera-phone access to views from a network of public and private Webcams.

Typepad — (www.typepad.com) — and **LiveJournal** — (www.livejournal.com) — Typepad is a blog host with moblog features. LiveJournal uses Typepad's blog publishing platform, Movable Type, and hosts a community of blogs and moblogs. Both offer paid hosting for moblogs.

Manila — (www.manilasites.com) — Blog host with moblog features and paid hosting.

Living Dot — (http://www.livingdot.com) — Blog host with moblog features and paid hosting. Also registers domain names.

WEB GALLERIES

If you have a digital camera, you're probably well acquainted with online Web galleries. These are the sites where you upload photos and sometimes videos to a personal album and arrange them in slide shows and other types of displays. Most gallery sites also allow you to order prints of the photos you upload, as well as gift items and other paraphernalia sporting your shots.

Online photo galleries were popular before the rise of blogging, video hosting and social networking, but many of them now incorporate some of those features. Still, the primary purpose of a gallery site is providing a place to present your images to people you know and, if you wish, the public.

Some gallery sites favor simplicity and automatic tools for people who just want to get their images online quickly in a decent-looking format. Others provide a large range of manual options for customizing the gallery's look, editing images, controlling print characteristics and exporting images to other sites so they can appear in online auctions or blogs. Some sites allow you to use your own domain name.

If you use only your camera phone and maybe a snapshot camera to take pictures, it probably makes sense to upload your images to a gallery that offers a modest range of features for free. Serious photographers who use a camera phone in addition to a more advanced camera should consider sites that charge an annual fee but offer more options. Many sites offer both free and paid album accounts, with the number of available features increasing with the cost. Make sure you understand a site's policies before you start creating albums there. Find out if image files will be discarded after a period of inactivity; and if you're going to use your albums as an archive, make sure the site will retain the original, full-resolution files and provide a way for you to retrieve them.

You can upload images to all of the sites listed in this section directly from a camera phone. (Read more about the various ways to do that in chapter 3, and check the site you're interested in to see if it supports the method you prefer.) Some of these sites offer special features for camera phones, such as the ability to view gallery albums and order prints directly from a phone. Sites that provide mobile software for your phone often let you download images from a gallery in addition to uploading camera-phone

shots, in case you want to use a picture as wallpaper or simply store it in your phone.

There are hundreds of Web-gallery options online. This is not a comprehensive list but it is a selection of sites that stand out for their general quality, mobile features or focus on a special interest.

dotPhoto — www.dotphoto.com — Provides many automatic tools for enhancing and presenting images, as well as an excellent selection of mobile features and software available through the affiliated Pictavision site.

flickr — www.flickr.com — You can organize your own images according to their tagging system. Search for other people's images by tagged information, or group your images with other images carrying the same tag. Also provides efficient tools for exporting images to other sites and blogs.

Geosnapper — www.geosnapper.com — Displays information about the locations where geocoded photos were taken and links them to a map. Also provides mobile software that automatically geocodes camera-phone photos and uploads them to the site.

iheartart — http://iheartart.org — Specializes in hosting camera-phone photos of art works, along with discussions and comments about them.

Kodak EasyShare Gallery — www.kodakgallery.com — Offers simple tools for image enhancement and presentation along with basic album-making. Special features include an integration with Skype calling that lets you present a slide show with a live voice connection to someone in another location.

MiShow — www.mishow.biz — Described as an "automatic multimedia scrapbook," MiShow arranges photos and videos sent from a camera phone or computer in a time-line-based slide show with music.

Phanfare — www.phanfare.com — Automatically uploads photos and videos from your computer to your online albums. You can also archive your photos here and they will send your images to you on disc if you cancel the subscription.

Photobucket — www.photobucket.com — Provides a simple interface for creating photo and video albums, and exports images to other sites and blogs. Also offers tools for transferring images between your Web album and camera phone.

Picturetrail — www.picturetrail.com — Offers easy-to-use tools for creating albums and many different types of slide shows, and exports images and slide shows to other sites and blogs.

SmugMug — www.smugmug.com — A good choice for serious photographers who use both a camera phone and an advanced camera and who want to present a highly customizable gallery with excellent printing and sharing options.

Snapfish — www.snapfish.com — Provides simple tools for organizing albums, enhancing images and creating slide shows. Lets you transfer images between your Web albums and camera phone, view albums on your phone and send images from your albums to other people's phones.

Webshots — www.webshots.com — Organizes albums around a home page that includes a personal profile and links to other people's public albums, and lets you search and download from a large collection of professional photos.

CAMERA PHONES ARE FOR PROFESSIONALS TOO: Photographer Evan Nisselson created an essay with a camera phone that he featured on his Web site with his digital and film photography.

CAMERA PHONE CINEMA

Just as inventive film makers learned to

work with the particular characteristics of digital-camcorder footage, they've also begun to explore ways to turn the look and limitations of camera-phone video to their artistic purposes. Camera-phone video often encourages — and sometimes requires — a certain intimacy

with the subject. That's partly because camera phones are less intrusive and uncommon than larger devices, and partly because the videographer usually has to move in close to capture a good image with a camera phone. This might explain why sex and personal relationships seem to be a central concern of the current camera-phone cinema.

CREATE A MOBLOG: Cellflix Festival 2006 winner, Mike Potter.

Music videos, shorts and even feature-length films have been shot on camera phones and shown on television, online and at film festivals. Judge for yourself how successful the auteurs of this nascent medium have been so far by watching some of its seminal works (or at least a movie trailer):

Nuovi Comizi D'Amore (New Love Meetings) — http://85.18.52.228/htmania/nuovicomizi — Inspired by Pier Paolo Pasolini's 1965 film Comizi D'Amore (Love Meetings), Marcello Mencarini and Barbara Seghezzi shot this 90-minute documentary with a Nokia N90. It includes interviews with 100 Italians about their thoughts on sex and love. In Italian with English subtitles.

SMS Sugar Man — http://smssugarman.com — Written and directed by Aryan Kaganof, this feature-length film was shot with Sony Ericsson W900is. It's set in Johannesburg and traces the story of Sugar Man — "a pimp with principles" — and his business associates.

Some Postman — This music video for "Some Postman" by the band The Presidents of the United States of America was directed by Grant Marshall and shot with Sony Ericsson K750is. Available on a number of video hosting sites, including YouTube and iFilm.

Getting your work seen You can post shorts and music videos on hosting Web sites for the world to see. Some of these sites can be viewed not only on computer screens but also on camera phones and other mobile devices. All of them let you upload your videos for free and provide community features such as the ability to comment on other people's videos, or to enter your videos in a particular user group or category. Some Web sites and mobile media channels that feature professionally produced work also have public hosting areas or accept submissions from independent video makers.

Numerous film festivals and contests accept work shot with a camera phone, although it's likely you'll be required to convert the video to another format before submitting it. In fact, you could submit a camera-phone film to just about any festival, assuming you have the software and expertise needed to convert it to an accepted format. However, there are some festivals dedicated to films shot with camera phones. Mobile-phone manufacturers and service providers also host competitions and festivals periodically; check their Web sites to see what's running now. As the makers of New Love Meetings assert on their Web site, "Today who does not make a film, it is because he has nothing to say." So get to work.

CAMERA PHONE FILM FESTIVALS:

Be Mobile — http://bemobile.makadam.it — Italian festival hosted by Makadam in conjunction with the Venice Circuito Off short film festival.

Cellflix Festival — www.cellflixfestival.org — Hosted by Ithaca College's Park School of Communications.

Mobile FilmMakers — www.mobifilms.net — Hosts camera-phone film festival jointly sponsored by Nokia and the Discovery Networks Asia.

Pocket Films Festival — www.festivalpocketfilms.fr — French festival hosted by the Forum des Images.

The Third Screen Film Festival — www.thirdscreenfilmfestival.com — Film festival hosted by Columbia College Chicago.

Zoie Films — www.zoiefilms.com — Hosts Cellular Cinema Festival and distributes camera phone video online and to mobile devices.

PUBLIC VIDEO-HOSTING WEB SITES:

Addicting Clips — www.addictingclips.com — Also lets you upload and download games.

Archive — www.archive.org — Emphasizes preserving many media types for posterity.

Blip TV — www.blip.tv — Provides tools for distributing uploaded videos to blogs and accepts video uploads directly from camera phones.

Google Video — http://video.google.com — Provides downloads of movies and TV shows in various languages.

Guba — www.guba.com — Also sells downloads of feature films and TV programs.

Ourmedia — www.ourmedia.org — Nonprofit site that emphasizes social and political engagement. Also hosts photos, text and audio files.

Revver — www.revver.com — Shares the revenue from advertisements attached to videos you upload.

YouTube — www.youtube.com — Emphasizes community features, provides tools for distributing uploaded videos to other sites, and allows private video sharing.

OTHER FUNDING AND DISTRIBUTION CHANNELS:

Atom Films — www.atomfilms.com — Mobile media producer that accepts video submissions.

Bravo!FACT — www.bravofact.com — Canadian foundation that provides funding for short video production, including camera-phone work.

Fuse TV — www.fuse.tv — Music-video Web site with public video-hosting area.

iFilm — www.ifilm.com — Streaming-video network for pros and the public.

MEDIA OUTLETS

By now, anyone with a television or an Internet connection has seen camera-phone images in coverage of major news events. When news breaks, bystanders with camera phones often are more likely to be on the scene than the press corps. If you capture a newsworthy event on your camera phone, you can submit it to a media outlet directly or through an agency. There also are some documentary and entertainment outlets that incorporate viewers' camera-phone images into their programs. New media outlets for camera-phone photos and videos are being created every day, so check the Web sites of your favorite television channels, programs and news media to see if they take submissions.

Agencies Some agencies specialize in providing images captured by amateur photographers and videographers to media outlets such as news programs, print publications and Web sites. Usually, you can send images to them directly from your camera phone by e-mail or MMS. Some require that you register with the agency before submitting images. When the agency receives newsworthy images, it tries to sell them to media organizations and obtain payment for you. The advantage for you is that the agencies know whom to talk to and how to negotiate payment. The obvious disadvantage is that they take a cut if your image is sold.

Agencies have different policies and payment arrangements. Read their terms closely so you understand who will have the right to publish your images and how much you will be paid for them. Look for information about who will own the copyright to images submitted, whether you will be credited for images by media outlets, and whether submitting images gives the agency exclusive rights to sell or use them. Make sure you're happy with all the terms before you start sending in your shots. Some agencies retain unused images in a stock-image database to sell at a later time. Here are a few to check out:

Cell Journalist — www.celljournalist.com

Scoopt — www.scoopt.com
VideoNewsCaster — www.videonewscaster.com

Documentary and entertainment programs Some independent production companies and larger organizations solicit camera phone videos to integrate into their programs. Check out Web sites for more information on what companies may be looking for and how submitted videos will be used. Here is one good example:

POVs Borders — http://guide-h.omn.org/POVBorders — POVs Borders solicits short videos for its ongoing American ID project. The producers are looking for "substantive videos . . . about what regular Americans like yourself think and feel about the USA and its role in the world."

Mainstream news outlets Many mainstream TV, online and print news outlets have

ACCESS AND AVAILABILITY: Because news happens everywhere, camera phones are quickly becoming a reporter's tool as these Palestinian youths discovered one day in Gaza City in 2005.

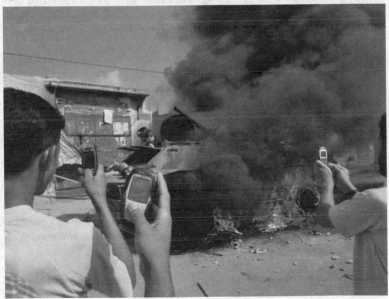

begun to accept camera-phone videos and photos of newsworthy events. Check the Web sites of those that interest you to see if they provide instructions for submitting images via MMS or e-mail. These major outlets solicit camera-phone images and provide instructions on how to submit them:

ABC News — http://abcnews.go.com
BBC News — http://news.bbc.co.uk
CNN — www.cnn.com/exchange/ireports/toolkit/index.html

Citizen journalism outlets Thanks to simple, inexpensive Web publishing tools and the fact that so many people carry camera phones these days, online journalism by people not affiliated with a traditional media organization has taken off in recent years. Usually called "citizen journalism," it's a new source of information for millions of readers and viewers. Some citizen journalism outlets are small publications that cover local news, while others are large sites with international coverage and editorial staffs. Some even include television outlets, and some offer payment for accepted submissions. Below are a few of the major citizen journalism outlets that accept camera-phone images. For a longer listing of outlets, take a look at the Citizen Media Initiatives List at www.cyberjournalist.net.

AgoraVox — www.agoravox.fr — French news and current-events site. Look for the link to "les moyens de publication" to find the address to send your images to via MMS. Sports images submitted may be published on the SportVox site (www.sport-vox.com).

Backfence — www.backfence.com — Neighborhood news publication that operates a separate site for each local area it covers.

Current TV — www.current.tv — U.S. cable and satellite channel that accepts news and entertainment videos. Video selected by viewers is shown on the Web, mobile devices or television. Selected contributors are paid.

OhmyNews International — http://english.ohmynews.com — Covers news and current events and accepts photos with articles submitted online. Available in English, Korean and Japanese.

Reporter.co.za — www.reporter.co.za — South African news and current events site that accepts photos with articles submitted online.

ART GALLERIES

It's probably safe to say that many art galleries

would be willing to show work created with a camera phone if it's sufficiently interesting— and if you can get a foot in the door. However, breaking into the art world is a topic for another book. If you're interested in showing your camera-phone photos or videos in a public exhibit and your agent is slacking off, submit them to one of the online exhibits listed below.

Art organizations that focus on new media and technology also are a source for information on galleries, Web sites and events that might show your work. Camera-phone manufacturers and service providers sometimes sponsor exhibits with submissions from the public, so check their Web sites to see if they have anything scheduled.

ONLINE EXHIBITS

15x15 — www.15x15.org — Inspired by Andy Warhol's famous speculation that in the future everyone would be famous for fifteen minutes, this site presents a continuously changing display of fifteen camera-phone videos. To be precise, the images change every fifteen seconds, the 15x15 people apparently not quite as generous with their attention as Warhol. To enjoy a fleeting moment of fame on 15x15, you can submit your camera phone videos via MMS, e-mail or a Web-based uploading tool.

Mobicapping — www.mobicapping.com — This online gallery presents an ongoing curated exhibit of photos and videos captured on camera phones, along with artist statements to accompany the selected work.

SENT — www.sentonline.com — Back in 2004, the SENT exhibit of camera-phone images was displayed in a Los Angeles hotel. That physical display was dismantled long ago;

but you can still view the images on the SENT Web site and add your own work to the collection. Both invited photographers and public contributors have submitted images to SENT.

NEW MEDIA ART ORGANIZATIONS

Blasthaus — www.blasthaus.com — Runs a gallery space, events and a multimedia production studio, and exhibited at the Mobile Phone Photo Show in 2004.

Rhizome — www.rhizome.com — An online new-media community site affiliated with the New Museum of Contemporary Art in New York. Hosts forums; publishes information about exhibits, projects and events; and maintains a searchable archive of existing work.

We Make Money Not Art — www.we-make-money-not-art.com — Publishes information about new media events, projects and exhibits in a blog format.

A NEW ART FORM: Camera phone photography has already been accepted as a new medium. It has been displayed in galleries, awarded prizes at art schools, and included in portfolio reviews.

CAMERA PHONE IMAGES IN COMMERCE

If you know about 2-D bar codes, you know they're a useful tool for the advertising industry. A bar code encodes a link to an online destination that can be accessed in your phone's Internet browser if code-reading software is installed on your phone. You can create these physical hyperlinks yourself using an online tool. Some bar code service sites allow you to encode existing URLs only, while others let you upload photos, videos and sound recordings, then encode a link to them. (Try Web sites such as www.kooltag.com, www.mytago.com, and www.shotcode.com to get started.) Ads, catalogs, package designs and store displays can include 2-D bar codes and invisible digital watermarks that camera phone software can read.

In a typical commercial interaction, 2-D bar codes and watermarks work like this: You open code-reading software on your Internet-enabled camera phone and take a picture of an item displaying a code or indicating it's marked with an invisible one. The code then automatically links to a server somewhere that sends you an ad, product information, a coupon, a ticket, a commerce page where you can purchase a product, or whatever else the vendor dreams up.

There are also ways in which companies have started to use plain old pictures with no special encoding to interact with consumers. Bandai Networks and D2 Communications created the "Search by Camera! ER Search" system, which is already in use in Japan. Consumers use their ER Search-equipped camera phones to take pictures of products shown in a catalog and send them to a site with a vast database of product images. The images are matched with product images in the database; and the corresponding product information is sent to the phone, including links for purchasing products right on the phone.

If you're dismayed at the prospect of businesses making use of your camera

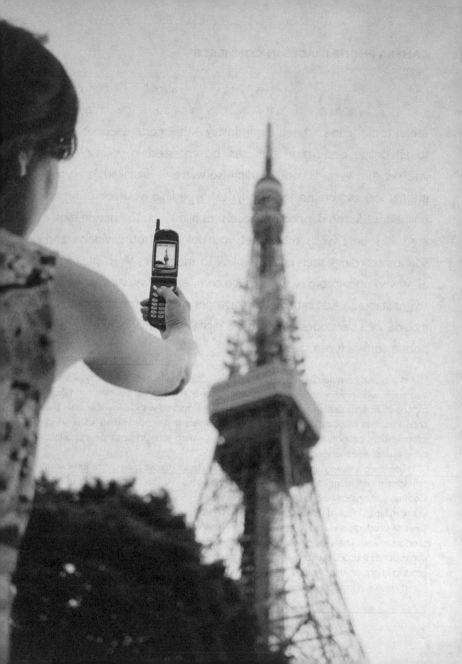

phone to acquire filthy lucre, consider this: Camera phones don't operate themselves. You decide when to acquire product information. Some other mobile-phone technology, such as Bluetooth, isn't as deferential to your preferences. An object or location that's emitting commercial media via Bluetooth can make an ad pop up on a compatible phone while it's still in your pocket or cause a commercial to start blaring at you from a nearby screen or speaker. Of the various mobile technologies likely to become widely used for commercial purposes, camera-phone-based technology is one of the best suited to offering convenient services with a minimum of intrusiveness.

You might also discover that your camera phone can come in handy when you want to make a little money yourself. Mobile classified and auction sites such as the British Text and Sell (www.textandsell.com) encourage you to put items up for sale directly from your phone and to upload camera-phone images of the goods you're selling via MMS.

Another aspect of camera-phone-assisted commerce you might find compelling is mobile price comparison. Amazon already provides a service in Japan that lets customers use camera phone bar-code-reading software to scan ordinary linear bar codes in a store, then receive a link by phone to related product information if Amazon carries the product.

This type of mobile comparison shopping service seems to have some serious implications for the way business is done on the ground. If customers can buy the products they see in a store from a distant competitor offering a lower price, how will physical stores compete? Will their profit margins shrink as they try to satisfy consumers who are always aware of products' retail price ranges? Will retailers lose out as more consumers buy directly from product makers? We won't know the answers to these questions until mobile commerce really takes off, but they make it clear that camera phones have the potential to affect more than the size of our snapshot collections.

Mobile phones in general provide an attractive outlet for "viral" advertising campaigns that encourage consumers to pass advertising material to each other quickly.

The more conventional approaches include ad campaigns built around camera-phone photo contests. Participants convince their friends to get involved in the competition by posting pictures of them and encouraging them to go to the Web site to see the photos that have been entered. More innovative strategies include personalized promotional material that consumers can distribute themselves. For example, a company called Personiva has created software tools that let you integrate your camera phone images into ads or music-video-style animations that accompany ringtones which you can send out to your friends via MMS.

CAMERA PHONE INFORMATION SOURCES

If you're buying a camera phone or just want to

keep up on the latest information about mobile-imaging hardware, software and technology, you'll find plenty of resources online (many more than can be listed here, in fact). Some of these Web sites are also linked to print magazines you can buy at a newsstand or bookstore.

When you're shopping for a phone, try to find reviews of the models that interest you from multiple sources. In product evaluation as in medicine, it's useful to get a second opinion. Many Web sites do a good job of reviewing phone designs and communication-related features but give minimal attention to image-capture functions.

Publications that have well-developed systems and labs for testing digital cameras are just beginning to give camera phones their attention — and thus just starting to give consumers the test results they need to choose a device that's good at capturing images. Surf through some of the sites listed here to find one that suits your needs. And keep an eye out for the camera-review sites to increase their coverage as camera phones become more popular and advanced.

Sources devoted to camera-phone coverage:
These sites focus exclusively on camera phones and mobile imaging.

Camera Phone Reviews — www.livingroom.org.au/cameraphone — Blog-format portal that provides news and links to camera-phone reviews published by many other sites.

Picturephoning — www.textually.org/ picturephoning — Blog-format site that provides up-to-the-minute news on camera phones and mobile imaging, along with links to many sites that cover mobile imaging.

Reiter's Camera Phone Report — www.wirelessmoment.com — Blog-format site that provides news on camera phones and mobile imaging, as well as many useful links to information on mobile TV and moblogging.

Sources that cover mobile phones and camera phones:

Cell Phone Hacks — www.cellphonehacks.com — Primarily a community site, with numerous discussion forums.

Cell Phone News — www.cellphonenews.net — News and reviews in a blog format.

Cellular-News — www.cellular-news.com — Provides phone specs and information on mobile-service providers, and publishes mobile-phone industry news, including financial, legal and technological developments.

CNET Reviews Cell Phones — www.cnet.com (Click on the Cell Phones link.) — Publishes mobile-phone reviews, buying guides, how-to features, news and user reviews. Also covers numerous other technology product categories; and CNET Networks include an international group of sites using the name CNET or ZDNet that publish reviews and other information in a variety of languages.

Consumer Reports — www.consumerreports.org — Publishes mobile-phone and service reviews and buying guides. Also reviews a wide variety of other consumer products and publishes a print magazine.

ON THE ROAD AGAIN: Robert Clark captured the spirit of America during a 50-day trip across America. You can see other photos at www.popphoto.com or www.robertclarkphoto.com.

Camera phones get a lot of abuse, and the better ones are built to take it. But even the sturdiest device can handle only so many drops, scratches, splashes, swims and smears before it needs fixing or at least a little spit and polish. The best cure for a damaged camera phone is prevention, so keep the lens cover shut (if you have one) and spend an extra few dollars on a protective case if you've shelled out a lot of money on the phone itself. When things go really wrong and you've lost images or have a waterlogged phone on your hands, look to this chapter for advice on providing first aid and getting professional help. There's also information on how your camera phone can do more good than harm when you've moved on to a new model.

BASIC MAINTENANCE

Lenses:Most camera-phone lenses are protected from dirt and moisture by a pane of glass or plastic. But even that surface can get dirty and affect the quality of your images. A small brush works well for removing dust and grit without scratching. Most camera stores carry camel-hair brushes, blower brushes and retractable brushes.

To remove smudges and fingerprints, use a small applicator containing a dry cleaning compound, such as Lenspen's CellKlear, which fits on your key chain. For a big lens, consider a larger Lenspen applicator with a brush on one end.

To clean dirt stuck to the surface of a lens, use a drop or two of lens-cleaning fluid on a microfiber cloth or a disposable lens-cleaning pad.

If you'll use your camera phone in a moist or humid environment, apply an antifog solution to both the lens and the LCD. Also consider using a waterproof case or a Ziploc bag if there's a lot of moisture in the air, to prevent damage to the phone.

Memory-card slots If your camera phone has a memory-card slot, keep the cover on when there's no card inserted to prevent dirt from getting inside. Some covers are completely removable and easy to lose. Be careful with yours because your memory-card slot could get so dirty from all the gunk in the bottom of your purse or your pocket that its functioning becomes impaired. If your camera phone is malfunctioning, try cleaning the memory card slot before you take it in for a service.

Various companies make cleaning cards for slots accepting SD, MMC and Memory Stick. If you're using a smartphone that has such a full-size slot, you're in luck. To clean the contacts inside, simply buy a cleaning card, insert it in the slot and remove. It's probably just a matter of time before companies start making cleaning cards that fit in mobile-media slots, so look around and see if anything has recently become available. Sticking random cleaning tools into a memory-card slot isn't a good idea. You might just push the dirt around or even add residue.

Memory-card contacts If the memory card itself gets dirty or corroded, purchase a contact-cleaning kit for polishing the metal contacts on it. These kits typically include cleaning

fluid, antistatic cloths and soft-tipped applicators. It's never a good idea to put a dirty card in a memory-card slot. When you handle your memory card, try not to touch the metal contacts. Doing so leaves an oily residue that can interfere with the card's functioning.

Battery compartments It's unlikely your battery compartment will get very dirty, since it's usually closed. But if it does, clean it with a brush, holding the phone so the dirt falls out and doesn't get brushed into the inside of the phone.

Don't use liquids to clean the battery compartment. You don't want moisture inside the phone or a wet moisture indicator. Many phones have a moisture-indicator sticker inside the battery compartment, on the battery itself or in both places. It changes color after being exposed to moisture, and mobile-phone warranties generally do not cover repairs to moisture-damaged devices. If you take in a phone with a discolored moisture indicator for repair, you will probably have to pay for it yourself.

Battery contacts Battery contacts are the pieces of metal on the battery and in the battery compartment that must be in contact for the battery to power the phone. Corroded contacts aren't a very common problem in camera phones since most people use their phones regularly, and their batteries are protected from corrosive elements in the environment. But corrosion can occur; and when it does, it can prevent the battery from powering the phone. Clean light corrosion and residue on flat contacts with a regular pencil eraser. Contact-cleaning pens with fiberglass tips for cleaning heavier corrosion are available in electronics stores. More delicate prong contacts risk being bent or broken by an eraser, so use a liquid contact cleaner on an applicator.

Avoid touching contacts— you will leave an oily residue that can interfere with the connection. If you're fastidious about maintaining electronic devices or want to get the absolute best performance from your camera-phone battery, buy contact lubricator in an applicator pen at an electronics store.

Cleaning and protecting the LCD Camera-phone screens can get smudged and yucky after a while. Clean them with an LCD-cleaning pen such as LensPen's DigiKlear, or with LCD-cleaning fluid on a microfiber cloth. You also can buy individually wrapped LCD-cleaning wipes saturated with cleaning fluid.

Most people don't put a protective cover on their camera-phone LCDs; but if the phone will be exposed to a lot of dust and dirt (or small children), you might want to use a screen protector. Screen protectors come in a variety of sizes at many office-supply, electronics and camera stores. They're transparent pieces of film that cling to the screen. They also can be handy for creating composition overlays such as a rule-of-

thirds grid. Screen protectors are also useful if you toss your phone in a bag along with your keys and want to keep the screen in pristine condition (although the screen protector won't help your lens).

Recovering accidentally deleted images If you accidentally delete images from your removable memory card, image-recovery software might get them back. Stop saving pictures to your memory card immediately after the mistaken deletion. Don't reformat it. Just leave it be.

When you delete an image from a memory card, you're taking it off the list of visible and accessible images. Although you won't see it, it will remain on the card until the space it's taking up is needed to store new images. If you reformat the card, all images— including deleted images— will be removed permanently.

Image-recovery software can search your memory card for images you can't see but are still stored on the card. To use it, connect your camera phone via USB to the computer where you've installed the software, or put the memory card in its adapter and insert the adapter in a card reader that's hooked up via USB to your computer.

Once you're connected, the card should appear as a drive or folder on your computer's file-browsing window. Open the recovery software and run the recovery process on the card.

Recovering images from the internal memory of a camera phone isn't as easy. To do that, the image-recovery software must detect the camera phone as a drive, which it doesn't always do. There are many free trial versions of recovery software, though, and there's no harm in trying one.

When you drop your phone in the lake, pool or toilet It can happen to the best of us. When it does, only one thing is for sure: Your warranty is now void. Most manufacturers and mobile-service providers

CLEANING-SUPPLY SOURCES

These companies make products for cleaning lenses, LCDs, battery contacts and memory-card slots. Some also make screen protectors and antifog solutions. Find their products in many office-supply, camera and electronics stores, and online.

Alpine Innovations
www.alpineproducts.com

Digital Innovations
www.digitalinnovations.com

Fellowes
www.fellowes.com

Hakuba
www.hakubausa.com

Hoodman
www.hoodmanusa.com

Kinetronics
www.kinetronics.com

Laserline
www.laserline.com

Lenspen
www.lenspen.com

Norazza
www.norazza.com

Photographic Solutions
www.photosol.com

don't cover moisture damage and they will check the moisture-indicator sticker in the battery compartment when you bring your phone in for repairs.

Don't clean the toilet with your camera phone in your shirt pocket and don't stand chatting in the rain without an umbrella. But also remember not to leave your phone in the bathroom when you take a steamy shower or in your pocket when you go for a sweaty run.

If your camera phone does get wet, here's what to do: If you dropped your phone in salt water, chlorinated pool water, a sticky drink or any other liquid likely to leave a residue, rinse it in distilled water or the purest tap or bottled water available. A residue left inside your phone can continue to damage it long after the moisture is gone.

Remove the battery. If your phone has a SIM and removable memory cards, take those out too. Rinse all these items in distilled water if they were exposed to a liquid other than pure water and blot them dry with a soft cloth or paper towel. Make sure the metal contacts on them are clean and free of residue. Clean them with contact-cleaning fluid on an applicator if necessary.

Absorb as much moisture as possible from the phone with a paper towel or soft cloth, turning the device to let liquid pour out of ports, jacks, speakers and mics.

Let the phone sit and dry. Don't try to turn it on until it's completely dry. This could take several days.

Make sure the contacts on the battery and in the battery compartment are clean and free of residue. Clean as recommended in the previous section if necessary.

If you aren't positive your phone is dry inside, shake it and listen for water. Look at the LCD under a bright light to see if there's any moisture inside. Only when you are satisfied it's fully dry, then insert the battery and SIM card and try to turn on the phone.

There have been reports on the Web of people using hair dryers, hot lamps or even ovens on low settings to speed the drying process. If you're in a big hurry, try one of these methods; but air drying works and is less risky.

If the phone still doesn't work, don't toss the SIM and memory cards. They may be perfectly fine and work in another phone.

Warranties and repairs Most camera phones come with a one-year warranty. Warranties generally don't cover damage caused by dropping a phone, getting it wet or otherwise physically damaging it. Many mobile-service providers and electronics stores offer replacement plans for a monthly fee that's usually less than $5. These will provide a replacement phone— although not necessarily a brand new one— for the model you own if you lose or damage it. However, some of these plans will charge you a substantial fee if you actually send in your phone for a replacement. If you buy an expensive camera phone, a replacement plan might be worthwhile. With a low-cost phone, you might prefer to back up your phone data and take the risk.

Repairs not covered by a warranty can be expensive when done by the phone manufacturer or service provider; and some companies won't repair certain types of damage. If you're unhappy with the options they offer, look for an independent mobile-phone-repair service that may offer more and charge less.

If you're handy with a solder gun and have nothing to lose, you can buy mobile-phone parts online. Look up your model on http://repair4mobilephone.org, which provides do-it-yourself information on repairing and modifying many phones.

Cell-phone safety There has been concern over the years about cell-phone radiation causing health problems. Studies have been inconclusive; but if you're concerned about it, the FCC publishes test results on cell-phone radiation-emission levels. To get the information on a particular phone, check CNET.com's cell-phone-radiation chart.

Getting rid of it According to Lyra Research, there already have been more camera phones sold than the total number of film and digital cameras ever sold. In other words, there are a lot of camera phones out there, and their number is only growing. And they all add up to a lot of electronics headed for the landfill.

You don't have to be Al Gore to understand that's not good. Camera phones and their batteries contain toxic materials that can leach into the ground and water where they're discarded. So, when you decide to upgrade to the latest model, don't chuck your old phone in the trash. Mobile-phone recycling programs and some charities accept used phones.

Stores of many kinds run mobile-phone recycling programs and allow anyone to drop off a used phone. Staples, The Body Shop and Whole Foods Markets are just a few. To find a service near you that accepts mobile phones, search your local area on earth911.com. Here are a few other resources for phone recycling:

RECYCLING SOURCES

CTIA—The Wireless Foundation Call to Protect
www.wirelessfoundation.org

Green Citizen
www.greencitizen.com

Phonefund
www.phonefund.com

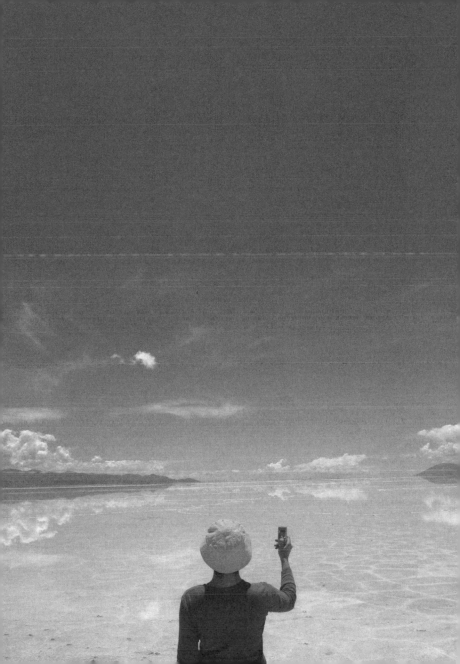

The Camera Phone Book
by Aimee Baldridge
Photography by Robert Clark

Published by the National Geographic Society
John M. Fahey, Jr., President
and Chief Executive Officer
Gilbert M. Grosvenor, Chairman of the Board
Nina D. Hoffman, Executive Vice President;
President, Book Publishing Group

Prepared by the Book Division
Kevin Mulroy, Senior Vice President and Publisher
Leah Bendavid-Val, Director of Photography
Publishing and Illustrations
Marianne R. Koszorus, Director of Design
Barbara Brownell Grogan, Executive Editor
Elizabeth Newhouse, Director of Travel Publishing
Carl Mehler, Director of Maps

Staff for this Book
Bronwen Latimer, Project and Illustrations Editor
Fran Brennan, Text Editor
Sam Serebin, Art Director
Mike Hornstein, Production Project Manager
Rob Waymouth, Illustrations Specialist
Cameron Zotter, Design Assistant
Ken della Penta, Indexer
Aled Greville, Managing Editor
Gary Colbert, Production Director

Manufacturing and Quality Management
Christopher A. Liedel, Chief Financial Officer
Phillip L. Schlosser, Vice President
John T. Dunn, Technical Director
Vincent P. Ryan, Director
Chris Brown, Director
Maryclare Tracy, Manager

Baldridge, Aimee
The camera phone book: secrets to making better pictures / Aimee Baldridge and Robert Clark.
p.cm.
Includes index.
ISBN 1-4262-0090-0
1. Photography—Digital techniques. 2. Cellular telephones. I. Clark, Robert, 1961-II. Title.

TR267.B335 2007
775—dc22

2006047020

Founded in 1888, the National Geographic Society is one of the largest nonprofit scientific and educational organizations in the world. It reaches more than 285 million people worldwide each month through its official journal, NATIONAL GEOGRAPHIC, and its four other magazines; the National Geographic Channel; television documentaries; radio programs; films; books; videos and DVDs; maps; and interactive media. National Geographic has funded more than 8,000 scientific research projects and supports an education program combating geographic illiteracy.

For more information, please call
1-800-NGS LINE (647-5463)
or write to the following address:

National Geographic Society
1145 17th Street N.W.
Washington, D.C. 20036-4688 U.S.A.

Visit us online at
www.nationalgeographic.com/books

For information about special discounts for bulk purchases, please contact
National Geographic Books Special Sales:
ngspecsales@ngs.org

CIP data available

Library of Congress Cataloging-in-Publication Data
ISBN-10: 1-4262-0090-0
ISBN-13: 978-1-4262-0090-8

Printed in Spain